kidsQuilt Together

The ABCs of Group Quilts

Kathy Emmel

C&T PUBLISHING

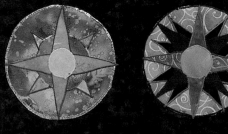

Text and classroom photos © 2005 Kathy Emmel

Quilt photos © 2005 C&T Publishing, Inc.

Publisher: Amy Marson

Editorial Director: Gailen Runge

Acquisitions Editor: Jan Grigsby

Editor: Cyndy Lyle Rymer

Technical Editors: Carolyn Aune, Wendy Mathson

Copyeditor/Proofreader: Wordfirm Inc.

Cover Designer: Kristy K. Zacharias

Design Director/Book Designer: Kristy K. Zacharias

Illustrator: Kerry Graham

Production Assistant: Kerry Graham

Photography: Quilt photos by Sharon Risedorph;
 classroom photos by Kathy Emmel

Clipart: Courtesy of Corel Gallery Clipart Catalog, Version 1.0

Published by C&T Publishing, Inc., P.O. Box 1456, Lafayette,
 CA 94549

Library of Congress Cataloging-in-Publication Data

Emmel, Kathy

 Kids quilt together : the ABCs of group quilts / Kathy Emmel.

 p. cm.

 Includes index.

 ISBN 1-57120-297-8 (paper trade)

 1. Quilting. 2. Quilts—Design. 3. Group work in art. 4.
Creative activities and seat work. I. Title.

 TT835.E486 2005

 746.46—dc22

 2005002650

Printed in Singapore

10 9 8 7 6 5 4 3 2 1

Thank you to my husband, John,
and children, Karena, and Dane
for their continuing support and
encouragement in pursuing my
love of quilting and teaching.

The classroom quilting projects
would not have been possible
without the help and support of
the following individuals and
companies:

Viking Husqvarna Corporation,
specifically, Nancy Jewel and Sue
Hausmann

Betty and Shelby Barnes of
Wallace Sewing Chalet in
Boulder, CO

Patty Albin, Viking Educator

Barb White, digitizing instructor
Sulky of America

Oklahoma Embroidery and Design

Hobbs Corporation

Stearns Technical Corporation

Pola Nye of G & P Trading,
Westminster, CO

Jo Ann Ginther of Dry Creek
Quilts, Broomfield, CO

IBM Corporation

Colorado Quilting Council
Scholarships and Grants

Program and volunteers who
helped in my classroom

Weber School PTA

Quilts by Sandi, Aurora, CO
(Sandi Fruehling)

Possibilities Publishing Co.,
Denver, CO (Lynda Milligan and
Nancy Smith)

Rupert, Gibbon & Spider Inc.
(Kim Meyer)

ProChem (Vicki Jensen, Lab
Manager)

Art teachers Cindy McConnell
and Holly Yates

Special friends Sandi Fruehling,
Mary Jo Smith, Diana Paul, Carol
Weber, Jeanne Yates, and Amy
Mundinger

Weber Elementary School teach-
ers Sue Gilbert, Pattie Courtney,
Heather Barbarick, Troy Brickley,
Shonda Kaspar, Liz Liley, Carol
Lochner, Teresa Williams, princi-
pals Jean Scharfenberg and Cheryl
White, librarian Jaci Maslowe,
technology educational assistant
Diane Puntenney, and numerous
parent volunteers.

Melissa, Stephanie, Douglas, and
Kathy May

And a special thank you to Pepper
Cory for encouraging me to dream
bigger!

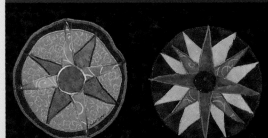

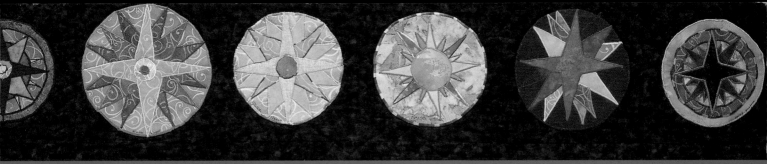

Table of Contents

Paramecium live
On
Nature's ground.
Down in the water you can
See the sun's shadow.

Autumn leaves are still on the trees,
Reflect in the water,
Exciting!

Frogs go
Under water looking for food.
Leaping and jumping,
Leaping and jumping,

Off the lily pads to catch a
Fly.

Now I know how they live.
And sometimes they are
Terrified of
Unusual creatures
Reacting horrified to
Every sound.

by Veronica, age 11

Introduction

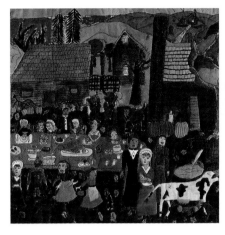 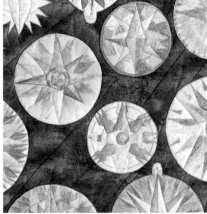 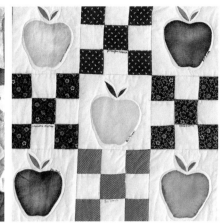

I began making quilts with my elementary school classes in 1987 after I had finished my Masters of Education Degree in Curriculum and Instruction: Creative Arts through the Outreach Program of Lesley College in Cambridge, Massachusetts. In the process of earning this degree, my own feelings about the importance and validity of instruction through the arts were reaffirmed.

Through my teacher training as a classroom and art teacher, I understood the importance of visual arts. I realized that teaching many subjects through the arts was an invaluable way to make learning more real for children. Over the next 17 years I made 17 quilts with over 600 children at the school where I taught for 24 years. In addition, I made quilts with smaller groups of children in Sunday school and camp settings. These classroom quilts as a collection represent a time and place where children interacted, learned, and led their lives. A former student (now in her late twenties) who is now a quiltmaker commented that the quilt she helped to create in 1987, *Nine-Patch Apple Quilt* (page 10), which was made using hand piecing and stenciling, was as much fun for her to make as the newer quilts are for students who use computerized sewing and embroidery technology.

The classroom quilts are often on display in the local library, and students leave me notes about seeing their quilt hanging there. Whenever I run into former students, they ask about their quilt. It was a high point of the year they spent in my classroom. Of course, it was also the first thing new students asked when each new school year started: "When are we going to make our quilt?"

With the advent of educational standards and testing, it became more and more important that the quilt project include as many aspects of the curriculum as possible. Most of the quilts revolve around a social studies or science theme, and integrated into that are activities from literature, language arts, reading, mathematics, computer technology, and, of course, art. In the Appendices, you will find a graphic organizer to help you plan an entire unit revolving around a quilt project.

I hope, however, that the most lasting effect of the classroom quiltmaking experience is an appreciation for people's artistic expression, especially in fabric. These students will forever know how much cooperation, learning, and hard work goes into completing a group project. And they will always be proud of the work they have accomplished and can share with others.

" Anything learned with pleasure is learned in good measure."

Thomas E. McNulty

Designing a Quilt

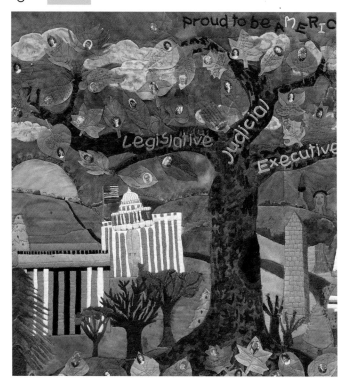

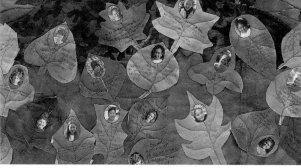

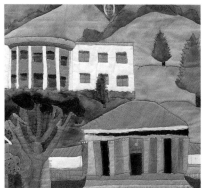

Quiltmaking with groups of children, in either a classroom setting or elsewhere, is an exciting experience for all involved. The focus can be for fundraising, charity, or gift giving. In the classroom or in a home-school environment, a quilt can be an all-inclusive project that incorporates many areas of the curriculum. However, designing a quilt to be made by a group of children presents many challenges. Critical to the success of any project is determining how to include the work of each student.

Choosing a Theme

The first decision to consider is the quilt's theme. You may choose a theme based on the quilt's purpose. For example, if the quilt will be used as a fundraiser (say, to benefit a fire station), you may choose to include artwork or symbols representative of the fire station, such as a fire truck, the station's symbol, and so on. Similarly, if the quilt will be given away as part of a charitable project, you may decide to gear it toward those for whom it is made, such as a quilt for premature babies or for women and children in shelters. Celebratory quilts may include blocks relating to an event or person, such as for the birth of a baby, a retirement, a marriage, or a memorial. Quilts that celebrate a location, such as a city, national park, or monument, may include visual images or symbols that represent the location. Holiday quilts might include symbols and colors associated with a specific holiday.

Another option is to choose a theme that revolves around the current curriculum. Familiarity with the state or school district's standards and benchmarks will help you better plan and incorporate these areas into your project. Social studies, science and literature

are good starting points for a class quilt project, but virtually every content area can be incorporated into the project. The following are just a few examples of themes pulled from content areas:

SOCIAL STUDIES Westward expansion; explorers; geography; a specific neighborhood, city, or country; Revolutionary or Civil War; colonial America; students' heritage; state history; Civil Rights Movement; famous people; historical events; the human condition (Dust Bowl, Holocaust, voting rights for women)

SCIENCE Life science (plants, environments, a pond, the mountains, plants and animals of a specific location), earth science (landforms, outer space, weather)

LITERATURE An author or poet, a specific book, or a form of poetry

Expand Into Other Curriculums

Once a theme is chosen, think about how you can expand it into different curricular areas. In addition to the obvious math skills required for quiltmaking, you can also incorporate language arts skills, literature, technology, and art, among others. For example, as students work on the quilt, you may assign additional activities, such as the following:

MATH Study measurement of angles, geometry and geometric shapes, symmetry, fractions, basic arithmetic functions, measurement in metric and standard units, graphing (make graphs describing the pieces in the quilt top and sort by size, shape, color, or amount), percentages.

LANGUAGE ARTS Write expository or fictional essays about the quilt; sequential directions for making a quilt; a poem based on the quilt; thank you notes to volunteers or to people who donated materials for making the quilt; business letters requesting donations for the project; a class newspaper with articles; a book about the project.

Students' writings bound into book form.

READING Research fiction and nonfiction about quiltmaking and about the quilt's theme.

TECHNOLOGY Videotape and create a movie of the project; use the Internet for research; use technology (such as HyperStudio or PowerPoint) to create a multimedia presentation about the quiltmaking project; scan artwork; incorporate graphics and word processing to produce a documentary about how the quilt was made.

MUSIC AND ART Perform dance, visual arts, or drama related to the theme.

> Organize the many skills to be taught during the quilt project by making a graphic organizer (see the organizer on pages 8 and 9 and Forms A and B in the Appendix pages 87-88).

sample graphic organizer

Quilt Theme: Explorers (Grade 5)

LANGUAGE ARTS

- ☐ Use the correct format for different types of writing (business letters, friendly letters, thank-you notes)
- ☐ Address envelopes
- ☐ Use expository writing
- ☐ Write directions
- ☐ Sequence events
- ☐ Write a script or narration

- ☐ Write a poem
- ☐ Write a fictional story
- ☐ Present an oral report
- ☐ Research background information
- ☐ Proofread, edit, and revise written work
- ☐ Write an outline

- ☐ Use correct spelling, grammar, and usage conventions
- ☐ Gather, record, organize, and integrate information
- ☐ Produce legible work, using technology when available or appropriate
- ☐ Incorporate cursive writing

MATH

- ☐ Use proportion
- ☐ Draft Mariner's Compasses using a compass and straight edge
- ☐ Use a protractor
- ☐ Learn about and use types of angles (acute, obtuse, and right angles)

- ☐ Bisect angles
- ☐ Use correct geometric symbols for lines, segments, rays, and angles
- ☐ Identify parallel, intersecting, and perpendicular lines, line segments, and rays

- ☐ Use fractions for multiplication, division, addition, and subtraction
- ☐ Measure using a ruler

SOCIAL STUDIES

- ☐ Gather information from many sources
- ☐ Create a time line
- ☐ Interpret data
- ☐ Chronologically organize information
- ☐ Describe historical events
- ☐ Identify and explain significant changes brought about by science and inventions

- ☐ Compare settlement in North America by various groups
- ☐ Interpret data in maps and other artifacts
- ☐ Given a list of quality of life indicators, select those most useful in describing the quality of life of a specific group in a specific time period (the Explorers)

- ☐ Sequence significant people in U.S. history through the Colonial period
- ☐ Sort and classify events by broadly defined eras in U.S. history

SCIENCE

□ Work as part of a team: make observations, analyze data, and draw conclusions

□ Understand interrelationships among science, technology, and human activity and how they affect the world

□ Understand how living things interact with each other and their environment

ART

□ Improve hand-eye coordination

□ Use of placement and composition in the design of the project

□ Recognize and use the visual arts as a language for communication

□ Select and employ basic components of the visual arts to solve visual problems

□ Use appropriate art vocabulary

□ Identify and experiment with a variety of materials, techniques, processes, and technology

□ Practice and demonstrate the skills of craftsmanship

□ Use arts materials and tools in a safe and responsible manner

□ Mix paint

□ Use watercolors and markers

□ Use a variety of brush strokes, and washes (dry brush, wet on wet)

□ Use a limited palette of color

TECHNOLOGY

□ Use a computer, printer, and scanner

□ Use a light table

□ Use computerized sewing machines

□ Use a computer and digitizing technology

□ Safely use an iron

□ Scan pictures and drawings

□ Import graphics into a text document

□ Record written scripts

□ Produce a computerized slide show with text, graphics, and narration

□ Use digital technology manipulation

□ Use a photocopier

□ Use an overhead projector

□ Use an opaque projector

Arranging the Blocks
columns and rows

If the quilt will be made of students' individual blocks, the arrangement of the blocks can present many challenges. Arranging blocks in columns and rows is probably the most obvious arrangement.

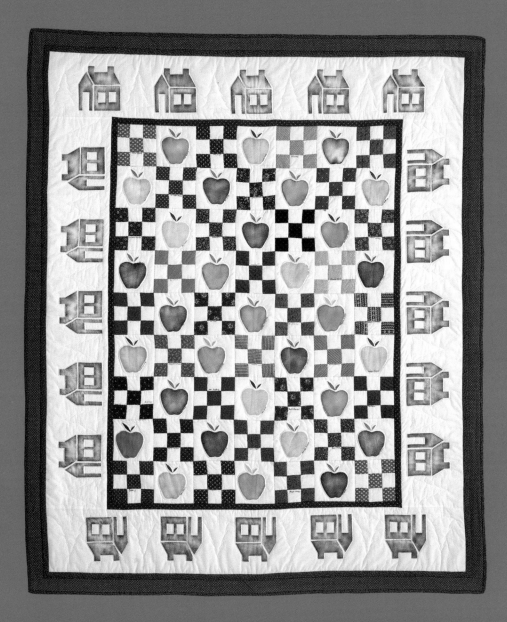

NINE-PATCH APPLE QUILT

65″ x 76″

made by Kathy Emmel's 1986–1987
4th grade class at Weber School, Arvada, CO

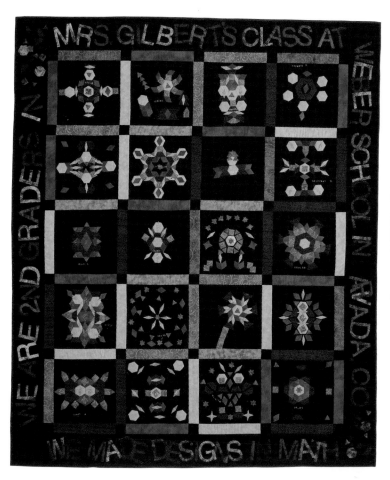

DESIGNS IN MATH: 2ND GRADE STYLE

70″ x 82″

made by Sue Gilbert's 2003–2004 2nd grade
class with Kathy Emmel at Weber School,
Arvada, CO. Quilted by Sandi Fruehling

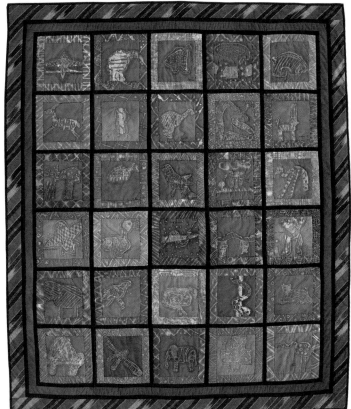

AFRICAN BATIK QUILT

60″ x 70″

made by Kathy Emmel's 1989–1990
4th grade class at Weber School, Arvada, CO

medallion quilts

Medallion quilts lend themselves to many themes. The medallion center in *Kindergarten Penguins of Antarctica* (page 17) illustrates the quilt's main theme while the surrounding blocks support the theme. Another medallion quilt, *Ms. Henneman's Awesome Alaskan Adventure* (page 21), uses a random arrangement of appliquéd blocks on the quilt top.

commercial prints

To add interest to a quilt, experiment with preprinted fabric for alternate blocks, sashing strips, or an interesting border. For example, *Haiku Quilt* and *My Family* both use preprinted fabric in the borders. Note also the stenciled schoolhouses in the border of *Nine-Patch Apple Quilt*, the stamped letters in *Designs in Math: 2nd Grade Style*, and the diagonal stripes in *African Batik*.

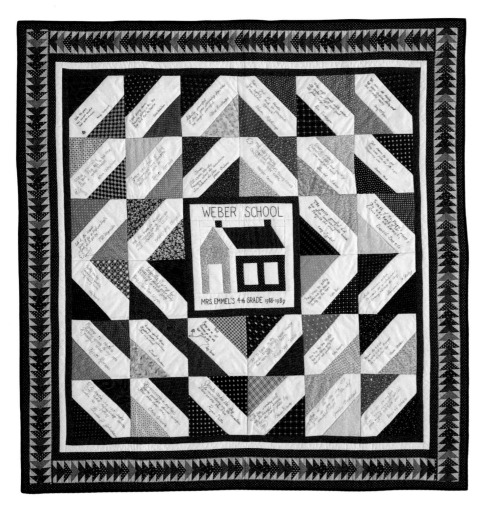

HAIKU QUILT

61″ x 61″

made by Kathy Emmel's 1987–1988
4th grade class at Weber School, Arvada, CO

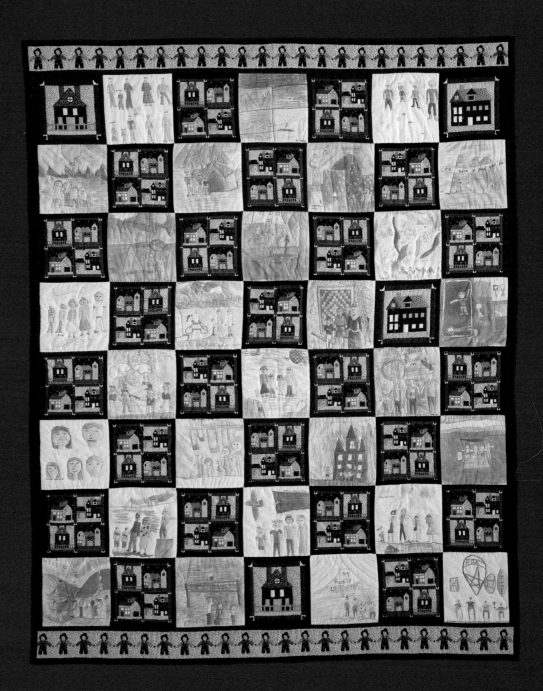

 MY FAMILY

69″ x 89″

made by Kathy Emmel's 1988–1989 4th grade class at
Weber School, Arvada, CO

floating blocks

Blocks can also be constructed so that they appear to float in the quilt. In *Class of 2001: Soaring Into the Future*, the background fabric in each star block uses the same fabric from the center of the quilt and the outer border. This subtle arrangement of rows and columns unifies the primary-colored stars while also making the stars appear to float in the sky.

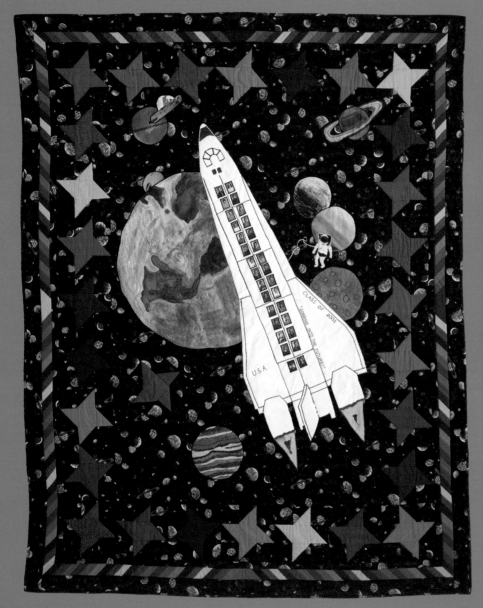

The background fabric gives this quilt a seamless appearance.

CLASS OF **2001**: SOARING INTO THE FUTURE

62″ x 80″

made by Kathy Emmel's 1993–1994 5th grade class
at Weber School, Arvada, CO

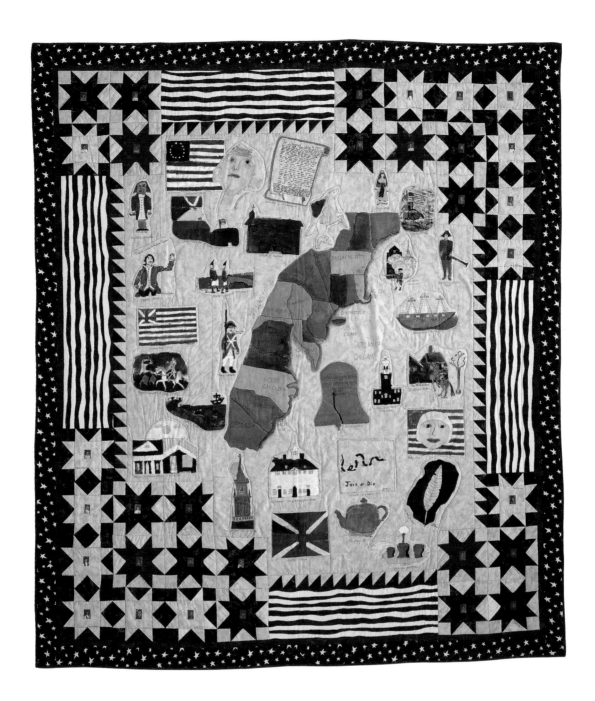

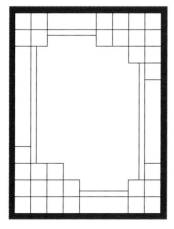

 REVOLUTIONARY WAR AMERICA

78″ x 89″

made by Kathy Emmel's 1994–1995 5th grade class at Weber School, Arvada, CO

Revolutionary War America uses alternating fabric colors of red, white, and blue in the star blocks to create positive (red or blue) and negative (white) stars. When placed next to the painted, appliquéd center panel, the star blocks with the white background fabric appear to float. The star blocks with blue background fabric in the upper-right and lower-left borders create a solid edge.

using quilt blocks in borders

Individual student blocks work well in the outer borders of a medallion quilt.

A class of 28 students created *Fishscape II*. The watery blue fabric of the block background and borders creates the look of fish swimming in water. Each student sewed a fish block for the border, and the "fish tank" interior includes individual student designs. Students drew and made the stencils, then used acrylic paint and toothbrushes to stencil their designs onto the large fabric panels that make up the three "tanks" (see Chapter 7, page 46).

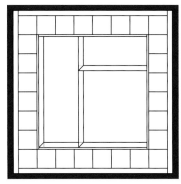

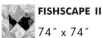 **FISHSCAPE II**
74″ x 74″

made by Kathy Emmel's 1990–1991 4th grade class at Weber School, Arvada, CO.

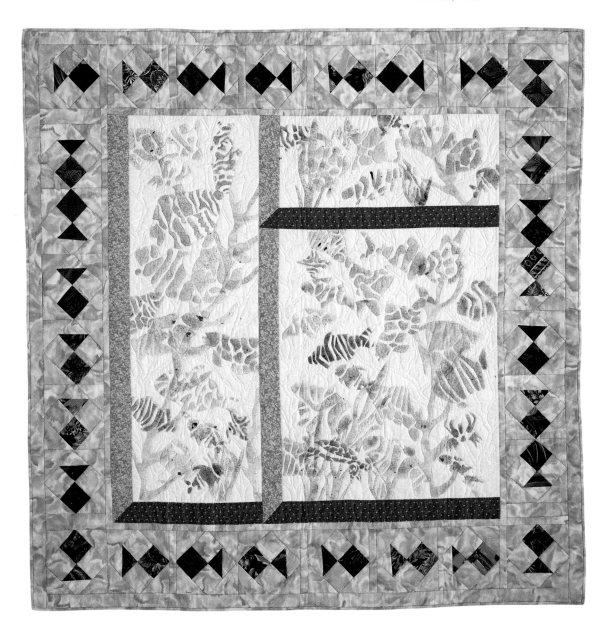

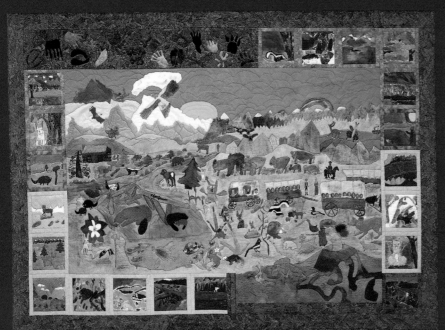

COLORADO: THE CENTENNIAL STATE
106″ x 66″

made by Patti Courtney's 2003–2004
4th grade class with Kathy Emmel at Weber
School, Arvada, CO. Quilted by Sandi
Fruehling

In *Colorado: The Centennial State*, twenty student-made blocks were added to the two side borders and to one upper and one lower corner of the quilt. A third corner provided space for appliquéd animal tracks drawn by the students, and the fourth corner became the "inside" of a prairie dog burrow.

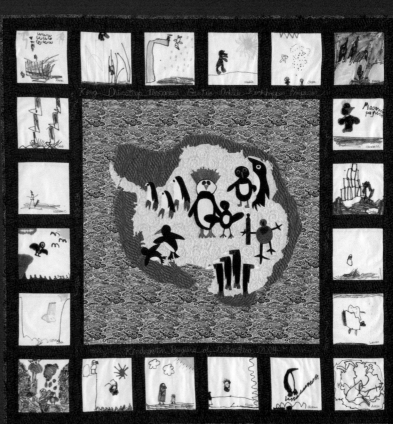

KINDERGARTEN PENGUINS OF ANTARCTICA
50″ x 50″
made by Amy Hodgson Mundinger and Barbara
Bogner's 2003–2004 A.M. kindergarten class at
Foothill Elementary School, Boulder, CO

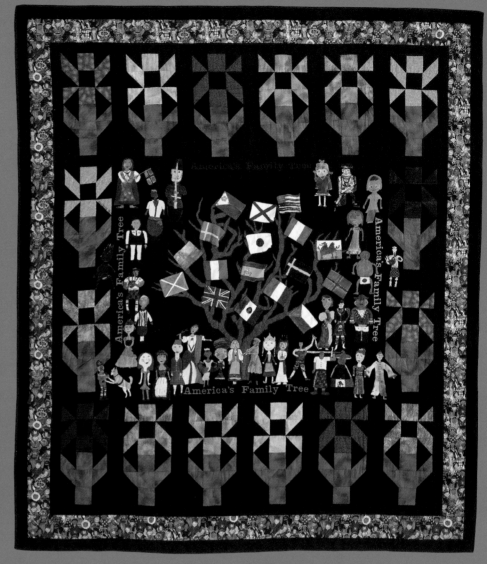

Students designed the two blocks used in America's Family Tree.

Another design idea is to combine two different blocks to make a larger block. In *America's Family Tree*, students used precut construction paper pieces to design blocks based on a Nine-Patch design. Two blocks were chosen and thirty-two students sewed the blocks (16 flower blocks and 16 leaf blocks) to create the flowers in the border.

AMERICA'S FAMILY TREE
78″ x 88″

made by Kathy Emmel's 1997–1998
5th grade class at Weber School,
Arvada, CO. Quilted by Sandi Fruehling

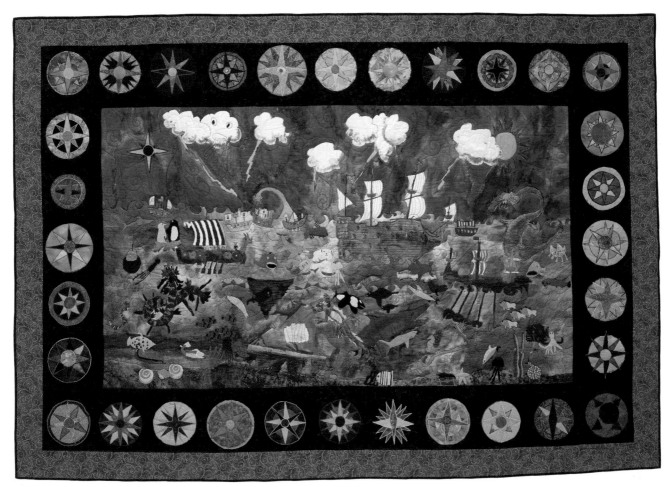

Sometimes a quilt is planned for a specific number of students but then the number of contributors changes. If a student leaves, another student may make the additional block. If a new student joins the class, be sure to include his or her work in the quilt. The design for *The Great Unknown* included 32 blocks for 32 students, but before the quilt was finished, a new student joined the class. In the sky at the upper-left portion of the painted section, a Mariner's Compass design was removed from the dark background fabric in the appliqué block and appliquéd into the sky. The student who created the original design was honored because his compass was chosen for the sky.

 THE GREAT UNKNOWN
115″ x 80″

made by Kathy Emmel's 1999–2000
5th grade class at Weber School,
Arvada, CO. Quilted by Sandi Fruehling

Unusual Block Settings

Another option is to design a group quilt that does not look like it was made by many people. *It's a Pond's Life* is an example of how a quilt constructed from many blocks can still look like a consistent whole—the use of color and fabric unifies the blocks. Although students chose their own color and fabric for the cattail leaves, they used the same background fabric and cattail stem fabric throughout. In addition, the design of the student blocks uses a horizon line that aligns with the horizon line in the center painted panel, providing the look of a quilt created by a single person.

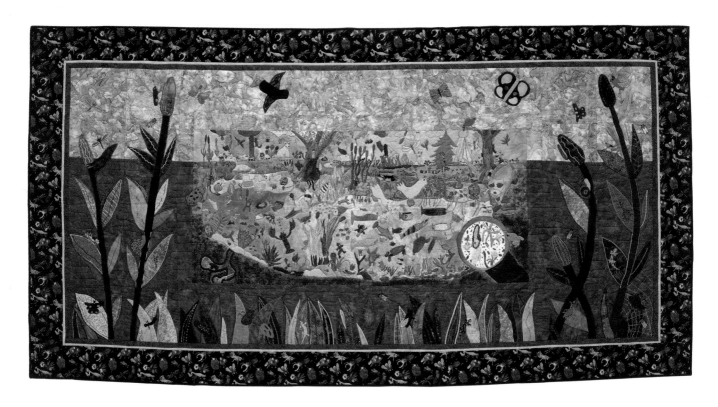

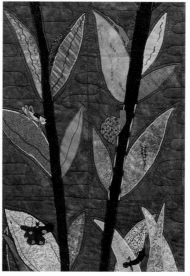

IT'S A POND'S LIFE
123″ x 63″

made by Kathy Emmel's 1998–1999
5th grade class at Weber School, Arvada, CO.
Quilted by Sandi Fruehling

The common fabric of the cattail stems provides cohesion.

Discovering the Universe uses an asymmetrical design layout. Blocks were arranged on one side and on the bottom of the quilt. The quilt's large section includes Mariner's Compass blocks drafted by students and transferred to fabric with fabric crayons (see page 44). The compasses were then appliquéd onto the larger panel. To create interest, some of the compasses extend into the border.

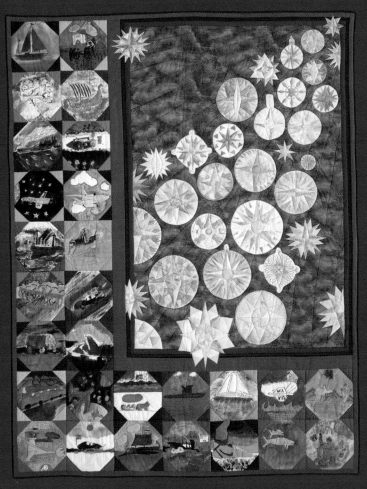

DISCOVERING THE UNIVERSE
68" x 86"

made by Kathy Emmel's 1991–1992 4th grade class at Weber School, Arvada, CO

MS. HENNEMAN'S AWESOME ALASKAN ADVENTURE
70" x 70"
made by Charlotte Henneman's 2003–2004 2nd grade class with Amy Hodgson Mundinger at Foothill Elementary School, Boulder, CO

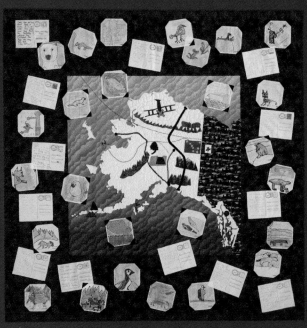

If you have more blocks in your design than students in your class, it may be necessary for some students to make a second block. To accomplish this, consider adding additional elements. For example, the design for *The First Thanksgiving* required 30 blocks, but the class had only 28 students. The teacher solved this problem by asking interested students to submit a drawing of a turkey. The class then voted to select two of the drawings to be painted onto fabric and included as additional blocks in the quilt.

For variety, notice how 32 blocks were incorporated into *See America* to create the nonrectangular center panel shape.

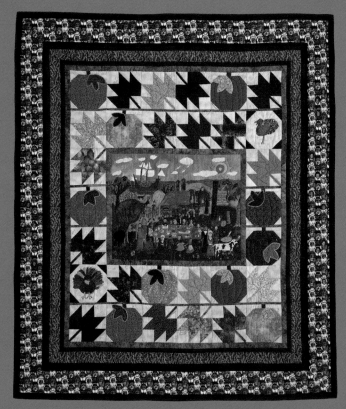

THE FIRST THANKSGIVING
80″ x 90″

made by Kathy Emmel's 1995–1996 5th grade
class at Weber School, Arvada, CO

SEE AMERICA
76″ x 86″
made by Kathy Emmel's 1996–1997 5th grade
class at Weber School, Arvada, CO

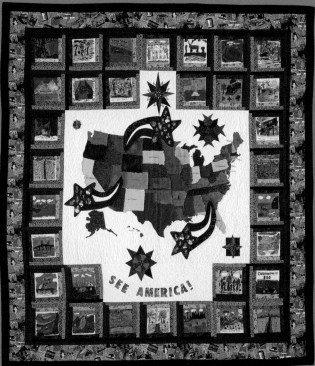

Very Large Group Quilts

Designing a quilt to be created by a large number of students can be a challenge. Two quilts—*Colorado: The Great Outdoors* and *Proud to Be American*—were each made by almost 100 sixth-grade students. *Colorado: The Great Outdoors* comprises 96 separate blocks, one made by each student, as well as a painted and embroidered center panel. *Proud to Be American* features 42 border blocks drawn and submitted by 42 students. The other 50+ students painted the center panel, which had been designed by many students. In addition, all students dyed fabric for an appliqué leaf containing his or her picture and thoughts on what it means to be an American.

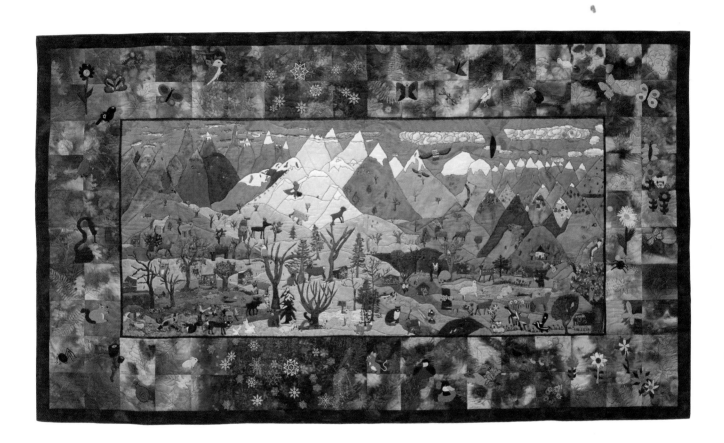

 COLORADO: THE GREAT OUTDOORS
105″ x 62″

made by Kathy Emmel with the 2001–2002
6th grade class at Weber School, Arvada, CO.
Quilted by Sandi Fruehling

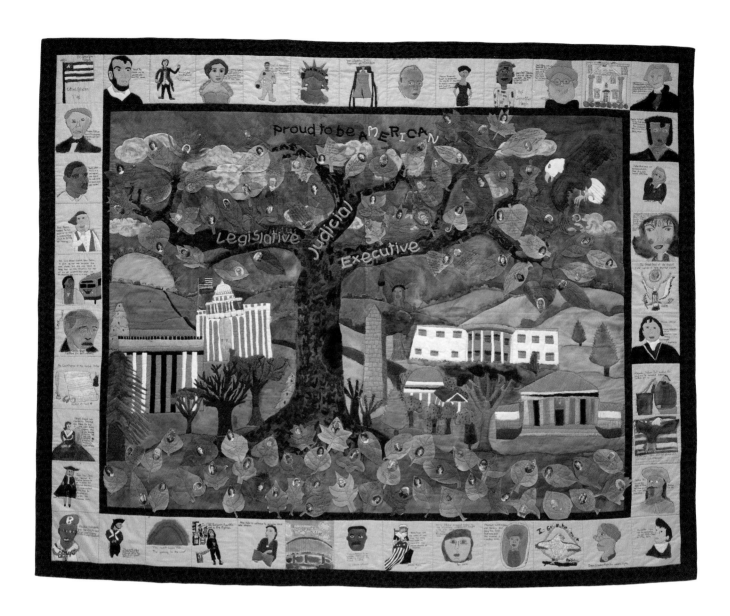

 PROUD TO BE AMERICAN

109″ x 86″

made by Kathy Emmel with the 2002–2003
6th grade class at Weber School, Arvada,
CO. Quilted by Sandi Fruehling

2 Setting Up the Room for Sewing

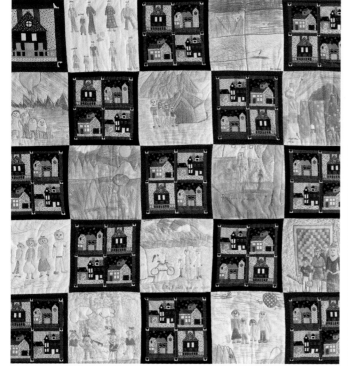

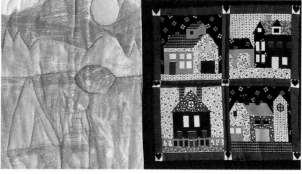

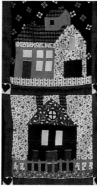

Carefully consider how to set up the room for quiltmaking. A large room is not necessary, but you should have space for some essential items and activities.

Sewing Setup

If students are hand piecing, they will need a solid surface (such as a desk or table) on which to put their supplies as they work. For machine piecing projects, you will need tables and chairs of the correct height for students who are sewing, with access to electricity for the sewing machines. If chairs are too high for short legs to reach the foot pedal, consider raising the pedals with wood, books, and so on. Place the sewing machine so there is table space on either side. Keep a pair of scissors at each machine. You may also need a power strip and extension cords to plug in all the machines.

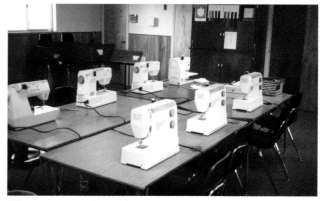

Classroom set up for machine piecing

For both hand and machine piecing, an ironing center is necessary for pressing seams. Set up irons away from the main work area. Station a volunteer near the irons to help students press their blocks. Supply each iron with an ironing surface, such as a pressing pad, an ironing board, or a travel ironing board.

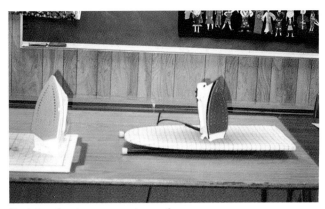

Each iron has its own pressing surface.

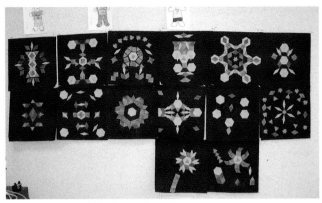

Display completed blocks on the wall.

When working with a small group in tight quarters, consider setting up one table near an outlet for the ironing center. For an appliqué project, such as *Designs in Math: 2nd Grade Style* (page 11), it is best to supply each student with a pressing pad on which to lay out the design. That way, each student can iron his or her block without picking it up and moving it.

Individual pressing pads allow students to iron their designs without moving them.

Designate a table for such supplies as pins, needles, thread, all the necessary fabric, tear-away stabilizer, fabric layout charts for blocks, extra scissors, and seam rippers. Display on the wall behind the table instructions for block construction. Be sure to pin up finished blocks so everyone can see the quilt's progress. At the end of the day, if your work area is not an established part of the classroom, have students help clean up and store the machines and supplies.

A Space for Sewing

If you don't want to dedicate your entire classroom to the project, or if you have no space at all, don't worry—you still have many options available. You may set aside one area of your classroom for the quilt project. Stock the project area with the supplies needed for the day, such as construction paper and layout sheets for block designing, so students can go to the center to work on the quilt during class. Or on a large table surrounded by chairs, set up a center panel to be painted by several students at once. Older students can set up their own paint palettes on foam plates (see page 38) and work on this panel without a lot of adult supervision.

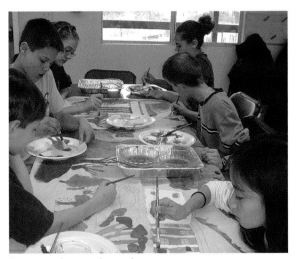

Painting a large quilt panel

If your classroom just doesn't have the space, look for other options in the building. Check on the availability of a classroom that is used only part time for activities such as band, drama, or special education. If a group of students is going on a day- or week-long trip, find out if their classroom is available. Ask the Library Media Specialist if a corner of the library can be yours for a day or longer. You can even set up in a large hallway. This last option creates a lot of interest on the part of other students and adults in the building!

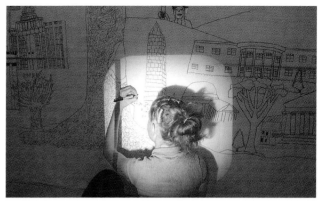
Project drawings onto a large piece of paper in the hallway.

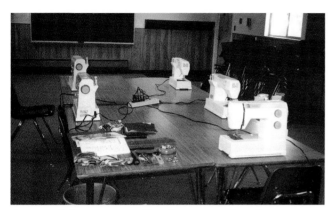
An unused classroom is excellent for sewing with students.

Large areas in the hallway may also be used for short-term aspects of quiltmaking. These areas are especially useful when using an overhead projector to trace drawings onto paper that will be transferred to the quilt (see page 36), or when tracing the drawing onto fabric using a light table. Share pictures of the quilt's progress with students, parents, and others in the building by displaying pictures on hallway bulletin boards.

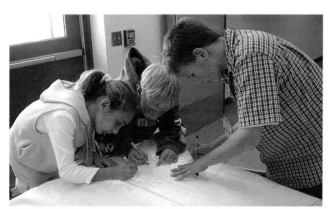
Set up a light table in a hall area.

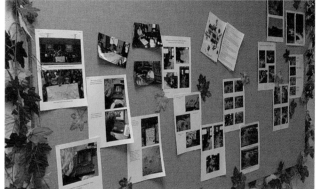
Display pictures of the quilt's progress.

If there is absolutely no space in your building, consider asking a local sewing machine dealer if you could hold sewing sessions at the store. The dealer might even be willing to supply the machines for your students to use. Another option is to work in a private home. Perhaps one of the student's parents has space that is appropriate.

A Time for Sewing

There is always time for doing a quilt project with a class, but sometimes it takes a little reworking of the schedule. The project can take place during the regular instructional day in the classroom. It can also occur during an art class, perhaps as a pullout program in which you work with the art teacher to complete certain aspects of the project. For example, for *Fishscape II* (page 16), students designed, cut out, and painted with their stencils during art class, but machine pieced their blocks in their regular classroom.

If funds for a substitute teacher are available, set up sewing machines and supplies in a separate classroom. While the substitute teacher continues with regular instruction in the main classroom, you can lead groups of students in their sewing session during the school day. If the students are sewing over a period of several days, you might want to use a rotating schedule (a schedule in which each group comes to you at a different time each day). This way, students will not leave the regular classroom during the same instructional period each day. They also will avoid having to do homework assignments in the same missed subject every night. See Form C (page 89) for a sample schedule.

For the sewing stage of the quilt, you might consider setting up small after-school sessions. It will probably take several sessions for all students to attend at least once. Make sure you get students to help set up and then clean up the supplies and machines needed for each after-school session.

Volunteers

One very important aspect of making a quilt with students is to use volunteers. Recruit volunteers from older students, parents, quilt guild members, PTA members, neighboring high school students, sewing machine store employees, or your friends.

Before volunteers arrive, instruct students on the importance of "please" and "thank you." Be sure to introduce the volunteers to students before beginning the project, and have name tags available for both students and volunteers.

Parents who volunteer usually prefer to work with a group that contains their own children. If possible, try to do this. Both the students and the parents appreciate it, and it gives parents who have taken time out of their busy schedules an opportunity to spend time in school with their children. It also gives them a chance to see their child in a setting different from the typical classroom environment. Often, it nurtures a new activity (sewing!) for parent and child to pursue.

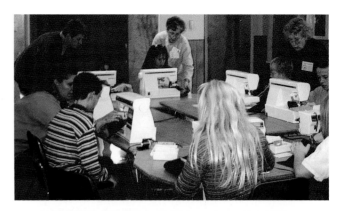

Parents and other adult volunteers are necessary for the success of a large project.

Communication with volunteers is of extreme importance. Ask for volunteers by letter (see Form D on page 90), and always send volunteers a reminder about the time and date for which they have volunteered (Form E on page 91). Include in the letter any pertinent information, such as where to park, how to enter the building, whether to bring any supplies (or lunch!), and how to check in with the office personnel.

Once the project is over, not only should you write a personal thank-you note, but also students should thank the volunteers who worked with them. Students should also write to thank any business or corporation that donated materials to the project. This is a great opportunity to teach students correct form for writing business and thank-you letters.

Remember, you can't do this project without the help of volunteers, so treat them as the special people they are!

3 Hand Piecing

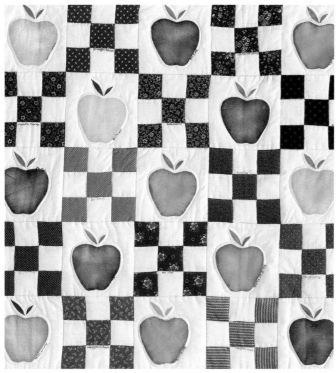

Most children love working with their hands, and sewing with a thread and needle falls into that category. Students as young as 5 or 6 can sew with yarn on an open-weave fabric, such as burlap or needlepoint fabric. Provide large-eyed, blunt-tipped needles, such as #16 tapestry needles. For sewing on more tightly woven fabrics, young students can use crewel embroidery needles, which have a large eye and a sharp point. Older students can learn to use regular sewing thread and needles. However, even older students appreciate the large eye of #16 embroidery needles.

If your class does not have a sewing machine, or if you simply want to teach your students how to sew by hand, consider the hand-piecing technique for quilting. Students design their own templates, trace the shape onto fabric with a pencil, cut out the fabric leaving a ¼" seam allowance, and hand piece their quilt block. Students will need to use scissors that will easily cut fabric. This method is especially good for fifth- and sixth-grade students making their own individual quilts. However, it is not an accurate enough technique for a large group quilt, which requires uniform blocks for accurate assembly.

Before hand sewing pieced blocks, teach students to accurately pin their pieces together. Demonstrate how to thread the needle, knot the thread, and do a running stitch. You will also need to show them how to knot the seam when finished by taking a backstitch over the last stitch made. Tell students that they should try to keep the size of the stitch and the size of the white space between the stitches to less than ⅛" to create a strong seam. Practicing first is always a good idea. Give students scraps of fabric with sewing lines

marked on them to practice pinning and sewing seams before starting on the final project.

It's a good idea to provide piecing diagrams for the block you are piecing. If you do want to use hand-pieced blocks for a large classroom quilt, assemble fabric kits for the students. To control the accuracy of the quilt blocks, precut all the pieces using precision cutting techniques employing a rotary cutter, a clear plastic ruler, and a cutting mat. (These supplies can be found in quilt shops, fabric stores, and craft stores.) Each fabric kit should contain precut pieces with the stitching lines marked for the quilt block, as well as thread, pins, and a needle.

For hand sewing, provide students with a needle that has a large eye (such as a #16 embroidery needle or a #12 crewel needle) so they can more easily thread the needle. After all, you don't want to have to thread all their needles. If students still have a difficult time threading needles, there are a variety of needle threaders available. For ease of threading, use hand-quilting thread rather than regular-weight sewing thread. The stiffness of the thread makes it easier for students to thread the needle and to tie a knot in the thread.

Use a needle with a hole large enough for students to thread.

Students in Holly Yates's art class printed designs on fabric and hand pieced Nine-Patch blocks for the backing to create individual pillows. Then they stuffed the pillows with batting.

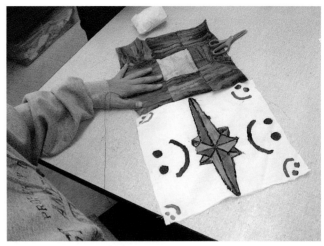

Nine-Patch pillow and printed pillow top

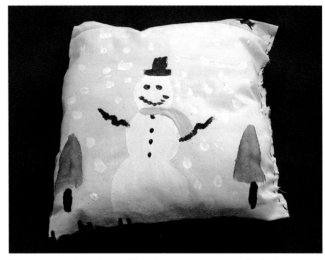

The opposite side of one pillow has a snowman made during a lesson in printmaking.

Students also enjoy using their needling skills for hand quilting.

1. Have students stencil their designs onto fabric (see Chapter 7, page 46).

2. Layer the designs with backing and batting and place in a round hoop.

3. Have students hand quilt around the stencil-painted areas, and possibly add quilted background features, such as animals or clouds.

4 Machine Piecing and Appliqué

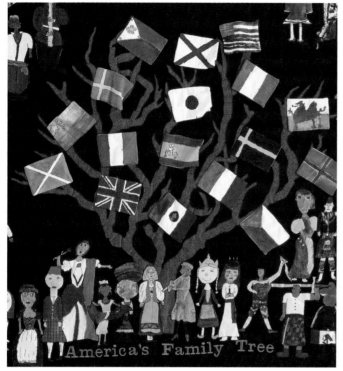

America's Family Tree

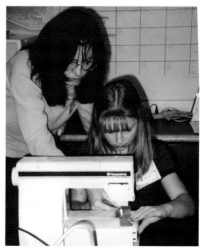

C hildhood is a great time to be introduced to the world of sewing. Age 9 or 10 seems to be an optimal time for boys and girls alike to learn to sew on a sewing machine. Students often get a thrill from using sewing machines, computerized or mechanical.

The best scenario is to have one student per sewing machine during each sewing session. You will also want to have one adult volunteer for every one or two machines to help students with threading the machine, sewing, solving problems, ripping out and redoing seams, and so on. Because students often want to "step on the gas" when operating the foot pedal, make sure they have a little practice before working on the actual quilt block. If the sewing machine has the capability of speed adjustment, set the sewing speed to the lowest level.

Supply each machine with a pair of blunt-tipped scissors for cutting thread.

Adult help is appreciated.

Machine Piecing

When the blocks for a quilt are going to be machine pieced, use a rotary cutter, plastic ruler, and cutting mat to precut the pieces for students, but don't mark any sewing lines on the individual pieces. Teach students to machine sew a ¼" seam on a piece of double-folded muslin, using the distance from the needle to the edge of the ¼" presser foot as a seam allowance. Students can practice by sewing parallel vertical lines ¼" apart. Students also often enjoy turning the fabric 90° and sewing another set of ¼" seams, creating fabric graph paper. After all this practice, students will be able to guide the presser foot against the edge of the fabric to make a ¼" seam when they piece their blocks together.

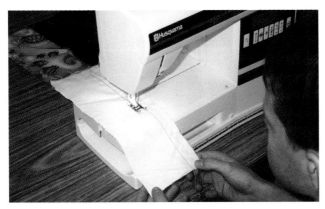

With practice, students become proficient at using a sewing machine.

This is a great opportunity for students to use a ruler in a practical setting. Students measure their seams by reading the ¼" mark on the ruler. Have them check to see if the fourth seam from the edge of the fabric measures at the 1" mark. Show them how two ¼" seams equal ½".

The Best of Sewing Machine Fun for Kids, by Nancy Smith and Lynda Milligan, contains some wonderful projects for teaching sewing skills. "Mouse Pivots" on pages 8–9 and "Climb the Peaks and Ride the Waves" on page 10 provide good opportunities for students to practice their stitching skills.

If you are using 100% cotton fabric, use 100% cotton thread.

Students can also use sample blocks and guide sheets to lay out the fabric for their blocks. Be sure to instruct them on the order in which fabric is pieced. One way to do this is to demonstrate, step by step, the actual construction of the block. For each step, demonstrate what to do, and then have students sew that step. Once all students have finished the step, continue with the next step. Be sure to demonstrate how to press the pieces after each step. Stress safety in using the iron: show students how to keep one hand on the handle while keeping the fingers from their other hand away from the tip of the iron. To help make the pressing easier, have students hand press the seams first, using their fingers or a wooden pressing stick.

With adult supervision, encourage students to press their seams without moving the iron back and forth.

Another way to instruct students in the construction of blocks is with a visual aid. For example, precut strips for a Log Cabin block to the exact size, and then display on a wall chart the order for assembling the fabric strips.

Wall chart for a Log Cabin block

Sample Log Cabin block *A student's finished Log Cabin block from* See America, *page 22.*

A layout sheet can also help students picture their block before sewing. It also shows them the logical order for sewing the pieces together. For example, for *America's Family Tree* (page 18), students placed their fabric on the graphic organizer so they could piece their block in the correct order.

Layout sheets for constructing blocks in America's Family Tree

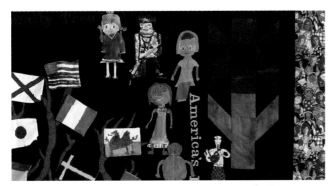

Two blocks equal one flower in America's Family Tree.

Machine Appliqué

Explain to students that in machine appliqué, the piece under all the other pieces is fused onto the background fabric first. They build the block from the "bottom" and work toward the "top." To help students with this concept, number the pieces on their paper pattern in the order of fusing (which is also the sewing order).

Cutting guide and numbering sheet for Mariner's Compass design

appliqué fabric paintings

Follow these steps if students, paintings will be appliquéd onto the quilt. Depending on the age of your students, you can do some of these steps or have them work on their own or with adult supervision.

1. Without trimming excess fabric from around the painting, iron the painting onto fusible web (such as Pellon Wonder-Under).

2. Tear off the paper backing and trim any extra fabric around the picture.

3. Hang the quilt top in the work area so students can pin up the appliqué designs to determine placement.

4. Once the placement is complete, iron the appliqués onto the quilt top.

5. Secure the appliqués to the quilt using a machine appliqué method. Check your sewing machine instruction book, refer to an appliqué book, or ask around to decide which machine appliqué method you like best.

Be careful not to get fusible web on the iron's surface. If you do, clean the iron with an iron cleaner (such as Dritz). Another option is to cover the painted fabric with an appliqué pressing sheet before pressing.

If students will be doing machine appliqué themselves, choose colorful threads for them to use. Many computerized sewing machines have a satin stitch. If your machine does not have a built-in satin stitch, set the machine to a wide zigzag stitch and adjust the stitch length so the stitches are close together. Be sure to use tear-away stabilizer under the project while sewing a satin stitch. The stitching will be easier to do and will look better.

Students enjoy using colorful threads on their appliquéd blocks.

appliqué practice

The following steps give students practice using fusible web and sewing shapes with a satin stitch. The two shapes allow students to appliqué along a straight edge, a curved edge, and a point. This practice session takes about 45 minutes to 1 hour.

1. Have students trace the quarter-circle and triangle shapes onto the paper side of fusible web. (See Form G on page 93.)

2. Cut out the shapes, leaving at least ½" around each shape.

3. Iron the webbing onto fabric (with the glue side toward the wrong side of the fabric). For younger students, you may need to do this step for them. Older students, however, can work under adult supervision in the ironing center.

4. Have students cut out the quarter circle and the triangle shapes on the drawn lines.

5. Remove the paper backing and iron each shape onto a square of fabric.

6. Apply tear-away stabilizer behind each piece. Have students practice satin stitching around the shapes. For an attractive stitch, use 40-weight rayon embroidery thread in the top and a 60- or 70-weight bobbin thread in the bobbin.

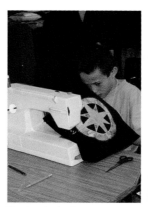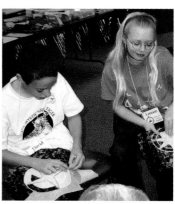

Sewing is the best part. *Removing the tear-away stabilizer is fun!*

Once students have practiced with the triangle and quarter-circle shapes, they can use their own pencil drawings as patterns for machine appliqué.

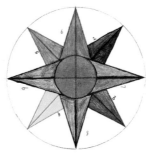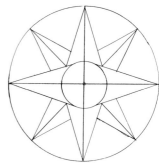

Student's original Mariner's Compass design

Student's Mariner's Compass design drafted using a compass and a straightedge

Using Fabric Paint in Quilts

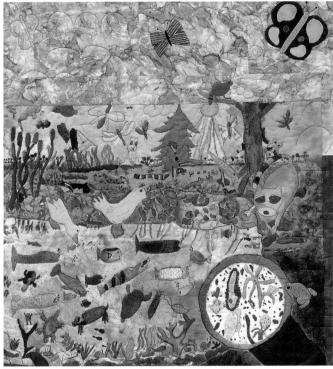

F abric paints and dyes allow students to express themselves using a medium that is colorful and permanent. This chapter outlines some important steps for creating compositions and using fabric paints on a quilt.

Creating the Drawing

If students will be painting a large portion of the quilt with fabric paint (such as the center in *Colorado: The Great Outdoors*, page 23), they first need to create the drawing. For large drawings, there are several possibilities.

creating a paste-up for enlargement

Cut a piece of white butcher paper the exact size of the quilt panel to be painted. Have students create a composition by taping or pasting their smaller drawings

to the large piece of paper. Preparing the drawing in this way is interesting for students, as they can see how it all comes together and are more likely to add more items. They are also quick to tell you what's missing!

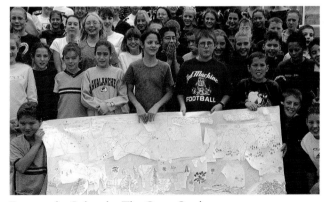

Paste-up for Colorado: The Great Outdoors

Once the composition is final, make sure all the smaller drawings are securely taped down before running the butcher paper through a blueprint enlargement copier, which can often be found at large copy stores, such as

Kinko's, or at a specialty engineering or drafting business. Paper in this machine comes on a 36"-wide roll, and drawings can be enlarged up to 400% on one run-through. So, if you are going to copy your design 100%, make the original the exact finished size (up to 36" wide and however long you would like it to be).

The blueprint enlargement copier creates a flat piece of paper that can be placed behind the fabric or on a light table for tracing. If you don't photocopy the original, the paper you trace will have lumps and bumps from the many pieces of paper and tape attached to it. Also, the thickness of several pieces of paper will make it difficult to see lines for tracing when using a light table.

It's a Pond's Life (page 20) is another quilt created using the paste-up method. In this case, each student sketched a design for the center panel on 9" x 12" sheets of paper. They then outlined their drawing with fine-tipped permanent markers. A black-and-white photocopy was made of each drawing before students filled in the lines with watercolor paints. These drawings served as the inspiration for the center drawing of the quilt.

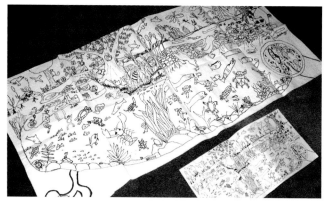

Original paste-up and 265% enlargement for the center of It's a Pond's Life

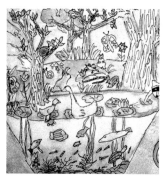

Student watercolors inspired the center drawing of It's a Pond's Life.

Each student cut pieces out of his or her photocopied line drawing and pasted them to the 11" x 22" paper that served as the main template. Once the template was complete, the paper was run through the blueprint machine and enlarged 265% to 29" x 58" to become the tracing copy for the quilt's center panel.

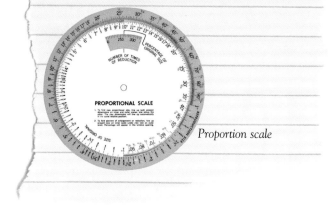

Use a proportion scale (available at copy stores, art stores, quilt stores, engineering supply stores) to help you determine the size enlargement or reduction needed.

Proportion scale

using opaque and overhead projectors

Two other machines for enlarging and transferring a drawing are the opaque projector and the overhead projector.

Opaque Projector

Insert the original paper drawings into an opaque projector. Focus the image and then enlarge or reduce it by moving the projector away from or toward the projected image.

Overhead Projector

Using an overhead projector provides more flexibility in arranging the composition as you go. Students enjoy having input in the actual design process as it happens.

1. Create enlarged or reduced clear transparencies of students' artwork using a copier, a computer laser printer, or a Thermofax machine (which is no longer produced by 3M Company but is still available in some schools).

2. Cut 2 pieces of butcher paper to the exact size of the panel to be designed. Tape or staple the pieces of butcher paper on top of each other to the wall.

3. Place each transparency on the glass of an overhead projector and project the image onto the butcher paper. Make sure the image is in focus before tracing.

4. Move the projector back and forth to enlarge or reduce the drawing to the desired size. The farther the machine is from the projected image, the larger the image. If you put the machine (in focus) as close to the wall as possible and the image is still too large, make a reduced transparency of the drawing. This is also one way to keep the drawings in the composition in proportion.

5. Trace the image onto the paper using markers or pencils, which can be traced over with marker after the paper is taken down. Markers can be used the first time around *if* the butcher paper is double thick so the marker doesn't bleed through onto the wall.

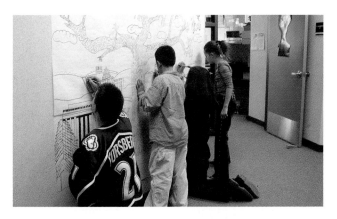

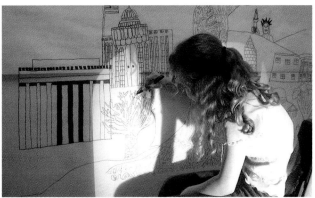

Tracing the projection from an overhead projector using permanent pens.

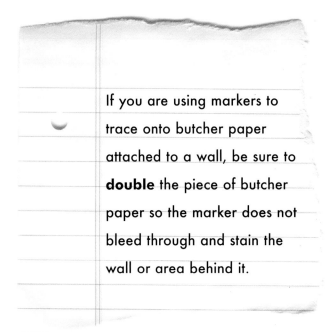

If you are using markers to trace onto butcher paper attached to a wall, be sure to **double** the piece of butcher paper so the marker does not bleed through and stain the wall or area behind it.

Preparing the Fabric

If students will be painting on fabric, use a fabric with a tight weave, such as Springmaid's Southern Belle, which has a thread count of 200 threads per inch.

100% cotton fabric works very well, or a cotton/poly blend will work as long as the weave is tight. Be sure to prewash the fabric before ironing to remove the sizing.

Before tracing the drawing, stabilize the fabric by ironing the waxy side of 18"-wide freezer paper to the back (or wrong side) of the fabric. The freezer paper temporarily adheres to the fabric and can easily be removed without leaving any residue. After the freezer paper is adhered to the fabric, tape the large drawing to the freezer paper with the right side of the drawing facing the freezer paper. Have students trace the drawing on the right side of the fabric using a large light table and permanent markers.

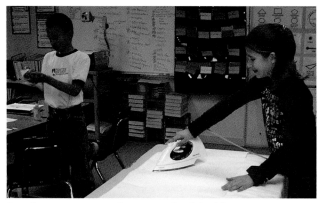

Iron freezer paper onto the wrong side of the fabric.

For smaller individual paintings, follow the same method of preparing the fabric. Students can use smaller light tables, such as Light Tracers, which are available at hobby, craft, and sewing stores. The prepared fabric can also be taped to a window for tracing.

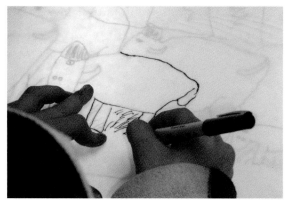

Using a large light table

Using individual Light Tracers

Leave the freezer paper and the drawing on the back of the fabric until the entire painting process is finished, as this gives the fabric more stability. After the painting is finished, remove the freezer paper, the drawing, and all the tape. To set the paint, follow the paint manufacturer's directions.

Setting Up the Painting Area

Most students are careful with fabric paint, but if you have doubts, cover any carpeted area and tables with plastic. Place all the paints, as well as foam plates, water containers, brushes, and paper towels, in one area that is also covered with plastic. In the same area, set up two buckets, one with clean water and a dipping cup and one for dirty water so students can change their own water without carrying containers in and out of the room.

Place all paint supplies in a central area.

Provide a variety of brush sizes, including brushes with fine tips for painting small areas and details as well as large, straight-tipped brushes (up to 1" wide) for painting large areas. Most craft and art stores carry inexpensive nylon or camel hair brushes that are made specifically for use with watercolors, acrylic, and oil paints. These brushes work well with fabric paints.

Provide plenty of small-tipped brushes for detail and small areas.

It is important to show students how to set up their work area and how to use the paintbrushes. Have students place their paint and brushes to the side of their work area, not on their fabric or area being painted. Otherwise, paint might stain areas they did not want to paint. Right-handed students should set up their work area so their paint and water are to the right of their fabric. This way, they won't be lifting a brush loaded with paint from their left side and carrying it over their fabric. Reverse the setup for left-handed students. Provide students with folded paper towels to keep by their paint so they can easily remove any excess paint from their brushes. This will minimize the risk of dripping paint onto areas where it is not wanted!

Show students how to set up their work area.

Painting the large center panel of a quilt requires a little different setup. Because many students could be painting at one time, place the fabric on one or two large tables with chairs all around. Remind students that it is easier to paint the large background areas after they paint the smaller detailed drawings.

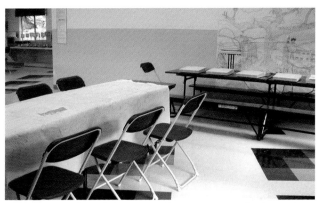

Arrange the table and chairs so students can sit on all sides of the area to be painted.

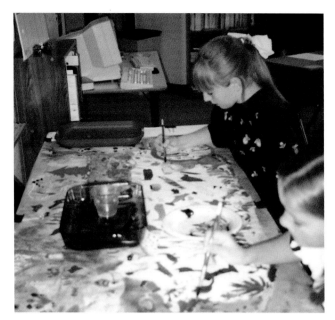

Paint small objects before filling in the surrounding large areas of color.

Place water containers inside a pan or dish so that if students spill water, they will not spill it on the fabric. Show students how to rinse brushes in water by gently swirling the brush in water and carefully wiping it against the edge of the water container. This protects the bristles from being crushed and keeps a good point on the brush. Encourage them not to hit their brush against the container's edge so the paint won't splatter on their neighbor's painting.

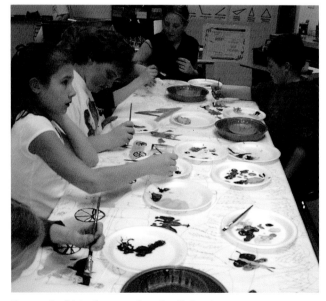

Protect the fabric from accidental spills by placing water containers in a pan.

Be sure students push up long-sleeved shirts so they don't get paint on their clothing. Paint shirts or aprons, if available, are useful. The paint will permanently remain on clothing—after all, it is fabric paint!

Fabric Paint Supplies

Many paints are available for painting on fabric. Local craft and hobby stores carry such brands as Jacquard, Setacolor, Delta Ceramcoat, Liquitex, Golden Tulip, and Fresco. Carefully read the descriptions on the label, as some of these paints may have three-dimensional puffy, matte, metallic, or pearl attributes. Some even glow in the dark! If you use Delta Ceramcoat, Liquitex, Golden, or other acrylic paints, add a textile medium to the paint at the ratio of 2 parts paint to 1 part textile medium. Textile medium is used with acrylic paint to help it bond properly to the fabrics.

Mix Delta Ceramcoat acrylics with a textile medium for use on fabric.

Textile medium

If you want the painted fabric to feel soft, use a textile paint such as Jacquard or Setacolor. These paints are creamy in texture. Thinning the paint with water makes it easier to spread on the fabric, but it lessens the intensity of the color and changes the consistency of the paint, making it watery. The thinner the paints are mixed, the more transparent look of watercolor it has. To create a more pastel or transparent color, add colorless extender to the paint. In this way, the paint will retain its consistency, but the color will be lighter and more transparent.

Jacquard paints come in large bottles or ½-ounce sampler sets.

creating a palette

Put a nickel-sized dollop of paint on each student's palette (foam plates work well as palettes). To lighten the color, students can then add a small amount of colorless extender. By adding white or black paint in a small portion, students can create a pastel or grayed tint of the original color. It takes some practice, but students usually catch on quickly.

Students need to know which area or object they are painting so they can choose appropriate paint colors for their palette. You can limit their color options, however, if you want to create a more unified look for the quilt, or just a section of it. For example, for large areas, such as sky, water, or grass, provide only certain shades of blue or green. In *The Great Unknown* (page 19), the teacher mixed colors for the sky and water before students began their work. These colors were the only blues students used to paint those areas.

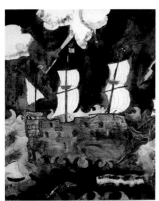

Create unity by using similar colors.

creating negative images with paint

With Setacolor Transparent paints, you can use objects to make images on fabric as long as the objects are somewhat flat and not too dimensional. The objects are placed on damp, painted fabric, then dried under sunlight or intense lamps (halogen or infrared heat lamps). The area covered by an object dries to a lighter shade than the surrounding area, leaving a negative image of the object.

> Use flat objects, such as real or silk leaves, because flat objects may be positioned directly on top of the fabric, which will leave a crisper image.

For the border of *Colorado: The Great Outdoors* (page 23), students used Setacolor Transparent paints to create blocks representing the four seasons. This quilt was made during January in the mountains, so natural leaves and flowers were not available. Instead, students used silk flowers, plants, and leaves from a local hobby store.

1. Follow the directions on page 38 for setting up the room.

2. Dilute Setacolor transparent paints for students by mixing 2 parts water to 1 part paint.

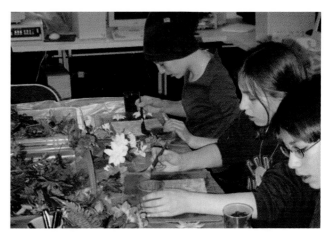

The block painting area is separate from the center panel painting area.

3. For each student, put a wet piece of precut white fabric (already cut to the final unfinished block size) on a masonite lapboard.

4. Have students use large brushes to add the diluted Setacolor paint to their blocks. Dabbing paint onto the fabric produces a cloud-like shape; long brush-strokes produce a smooth color.

You may want to set out particular colors for each student or group of students, depending on what they are creating. For example, in *Colorado: The Great Outdoors*, colors representing the different seasons were set out for groups of students.

Setacolor textile paints were used on the Colorado *quilt.*

5. Place objects, such as pieces of leaves and foliage, on the painted blocks. Other good objects include buttons, lace, rice, doilies, coins, metal objects, or paper die-cuts such as those used in scrapbooking.

Flat objects leave a crisper edge.

6. Set the lapboards under halogen or infrared heat lamps to dry. You may try leaving the boards outside in the sun to dry. However, if the wind comes up, the objects on the fabric will shift or blow off, which creates a fuzzy border on the negative image or no image at all.

Carrying a block on a lapboard is easy.

7. Once the fabric is dry, remove the objects and heat set the paints (see below).

Heat Setting the Color

Carefully read the paint manufacturer's directions for heat setting color created by fabric dyes and paints. The colors are usually heat set by ironing. Allow the fabric to dry, then iron the reverse side. Use a heat setting that is correct for the type of fabric and place a pressing cloth between the iron and fabric. Hold the iron in place (moving slowly to prevent scorching) for about 1–2 minutes.

Washing

Carefully read the washing directions for the paints and dyes you are using. Setacolor recommends waiting 48 hours before washing or dry-cleaning your fabric. Either dry-clean the painted fabric or machine wash on a gentle cycle using a mild soap, such as Orvus. Air dry.

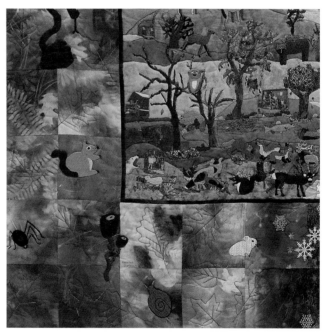

Colorado: The Great Outdoors *quilt squares for autumn and winter*

> Kosher salt can be sprinkled on the wet, painted fabric to create a "star burst" effect.

cold-wax resists

You can also use batik methods to make a classroom quilt. In this method, you apply wax to the surface of the fabric and then either dye or paint the fabric. You then remove the wax, leaving a negative impression of the image.

There are several ways to apply wax to fabric. You can apply hot wax (paraffin wax, microcrystalline wax, batik wax, or beeswax) to fabric using a Tjanting tool (wax pen). This technique is better for older students age 10+ who are working with adult supervision. After the wax is applied, dye the fabric in an immersion bath, or apply dye or paint to the fabric with a brush. Remove the wax by pressing the fabric between sheets of unprinted newsprint with a hot iron. This will melt the wax into the newsprint. Continue pressing with clean pieces of newsprint until the wax is removed.

> **Hot wax can be dangerous to use with young students, so many precautions must be taken.**

Another option, which is better for students under the age of 10, is the cold-wax resist technique. This is a liquid wax that can be applied using small fabric paint squirt bottles, a brush, or a stamp. Note that immersion dye does not work well with cold wax, because the cold-wax resist is water-soluble and will dissolve in the dye bath. Therefore, apply color (either fabric paint or dye) with a brush. After applying the wax and painting the fabric, remove the wax with warm water.

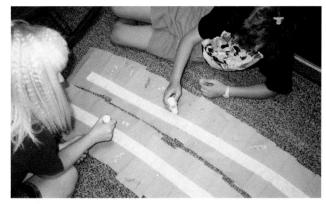
Students apply cold-wax resist to fabric using squirt bottles.

Batik quilt made using cold-wax resist and Rit dye.

6 Using Crayons and Fabric Markers

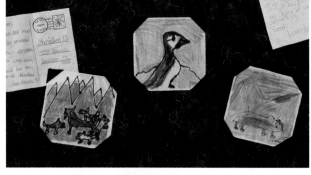

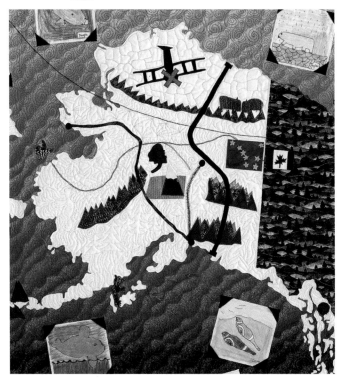

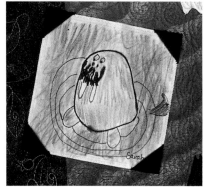

In addition to fabric paints, there are many other ways to apply color and drawings to quilts. Crayons and fabric markers are two tools that are easy for students to use.

Crayons

There are two types of crayons that can be used to apply color to fabric: fabric crayons and regular crayons.

fabric crayons

Fabric crayons (which come in only eight colors) may be found in the notions section of sewing or craft stores. These crayons are made specifically for fabric because they have a lower melting point than regular crayons. Old fabric crayons lose their color intensity, so it is worth buying a new set for each new project.

Fabric crayons

1. Apply the colors to a nonglossy paper, such as newsprint. To get a good, colorful transfer, the color must be applied with heavy pressure. Any letters or numbers in the drawing must be written in reverse.

2. Use a hot, dry iron to transfer the color to fabric. To do this, place the newsprint on top of the fabric (colored side of the paper toward the right side of the fabric) with a clean sheet of newsprint between the fabric and the iron. Press, applying pressure. The crayon will melt into the fabric.

Note: The color will be more permanent if the fabric is at least 50% synthetic.

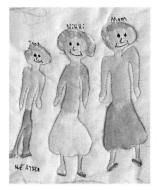

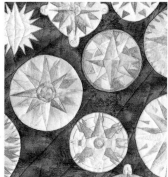

A block colored with fabric crayons

Mariner's Compass designs created with fabric crayons

regular crayons

Regular crayons may be drawn directly onto the fabric. Use 100% cotton fabric and stabilize it with freezer paper. In *Mrs. Henneman's Awesome Alaskan Adventure* (page 21), students drew their original drawings on paper and then used a light table to trace their drawings onto fabric backed with freezer paper and a thin-tipped permanent marker. Next, students colored directly onto the fabric with crayons, then ironed the fabric to heat set the crayon.

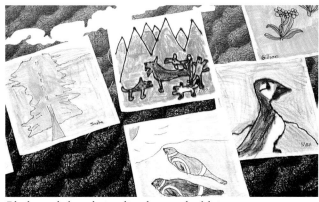

Blocks made by coloring directly onto the fabric

> Crayon colors tend to fade over time, so keep the quilt out of direct sunlight.

Fabric Markers

There are many brands of fabric markers on the market. Experiment to find the look and availability of colors you like. No matter which brand of fabric markers you use, be sure to read the manufacturer's instructions. Prepare fabric by ironing the wrong side of the fabric to the waxy side of freezer paper. This gives the fabric stability, making it easier to handle while drawing. Setaskrib fabric markers from Pebeo

have intense color, cover well, and do not bleed. Deco fabric markers cover well but are a little more liquid and can bleed slightly. FabricMate markers with a chisel edge have a "magic marker" look. Zig Write pens and thin-tipped Pilot pens make a clean, fine line if not held for too long in one place.

Blocks colored using Deco fabric markers

Many brands of fabric markers are available.

Pastel dye sticks, such as those made by Pentel, create a brilliant color when applied to fabric. They have a creamy texture and are easy to use. But be careful! They are also easy to get onto clothing. Consider having students wear paint shirts or aprons and rolling up their sleeves when using these fabric markers.

Note: Some markers need to be heat set, so be sure to read the manufacturer's directions.

Pentel Fabricfun pastel dye sticks

7 Stenciling

Students often enjoy the magic of stenciling. Stenciling on fabric presents many creative possibilities for creating a quilt. Stencil individual blocks and piece them together, or stencil many designs into a large area for a collage. You may also decide to stencil the border of the quilt.

Types of Stencils

You may either purchase stencils or have students design their own. For younger students, an adult should cut out the designs. Older students can cut out their own stencils. One easy method for students is to cut stencils from flat foam trays.

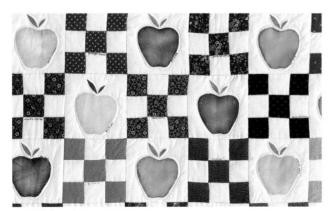

Stenciled apples

Purchased stencil

1. Remove the raised edges of the foam tray.

2. Have students draw their designs directly onto the foam using a pencil.

3. Place the foam tray on a self-healing cutting mat or other protected area, and use a craft knife (such as an X-Acto knife) to cut away the open areas.

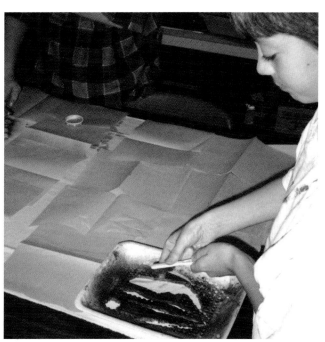

Using a stencil made from a flat foam tray

Fabric for Stenciling

Stencils can be applied to many types of fabric. For example, poly/cotton blends (similar to T-shirt material) work well. For quilt squares, use fabric similar to the rest of the fabrics in the quilt. If your quilt uses muslin, buy good quality muslin with a tight weave.

preparing fabric

To prepare the fabric for stenciling, prewash the fabric to remove the sizing. Iron and cut the fabric to the desired size. Use masking tape to attach the fabric to a hard surface, such as a masonite lapboard. Then tape the four corners of the stencil (right side up) to the fabric to keep the stencil from moving during the stenciling process. Commercial stencils have a "right"

and a "wrong" side: often the wrong side is bumpy and the right side is smooth. Any writing on the stencil (such as a company name, logo, etc.) is readable from the right side. When students make their own stencils, have them mark the right side with a permanent pen so the stenciled image will remain true to their original design.

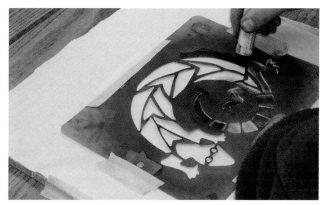

Tape the fabric to a hard surface, and then tape the stencil to the fabric.

Paints for Stenciling

There are many options for applying paint to stencils.

oil paint sticks

One of the easier methods is to use oil paint sticks (such as those made by Shiva), which are held the same way as crayons.

1. Provide students with stencil brushes, which are stiff and have a flat tip.

2. Have students use a paint stick to draw a line of color on the stencil (not the fabric) around the edges of the cutout area.

Then have them fill in the cutout area by using a sweeping motion with a flat-tipped brush to transfer the paint from the stencil to the fabric. Brush from the edges of the cutout area toward the center of the opening onto the fabric. Many students want to cover the cutout area with a thick, opaque covering of stencil paint. Encourage them to use a lighter touch to create the wispy, transparent look that is traditional with stenciling.

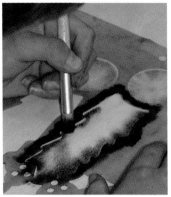

Apply color using a sweeping motion.

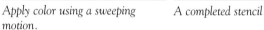

A completed stencil

> **Encourage students to use a light touch. The oil paint does not need to be thickly applied.**

When using oil paint sticks, assign a brush to each paint stick and have students use the brush with only that color of paint. Otherwise, colors may become contaminated through mixing.

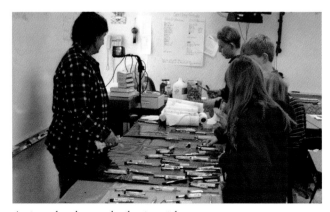

Assign a brush to each oil paint stick.

fabric paints

Students can use a foam plate for a palette.

1. Tape the fabric to a lapboard, then tape the stencil to the fabric (see page 47).

2. Put a small amount of the colors to be used on the foam plate.

3. Dip the tip of a stencil brush or a moist sponge (not too damp) into the paint. Be careful not to get too much paint on the brush or sponge.

4. To remove excess paint from the brush, dab it up and down on a paper towel.

5. Hold the brush or sponge upright and dab the color onto the stencil's open areas.

Another method is to splatter the paint onto the cutout area of the stencil using a toothbrush. With this method, use either acrylic paints mixed with a textile medium or fabric paints. Be sure to give students a chance to practice this method before using it on the final product.

1. Tape the fabric to a hard surface covered in plastic. Cover the surrounding work area with paper towels to protect them from splattered paint.

2. Put a small amount of colors to be used on a foam palette.

3. Gently dip the toothbrush bristles into the paint.

4. Use the index finger to "splatter" the paint onto the fabric by running the finger against the bristles.

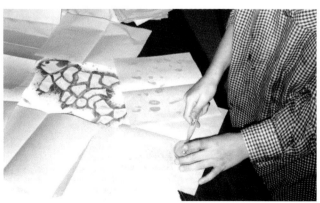

Use a toothbrush to paint a stencil.

completing the stencil

Oil paint stick-stenciled fabric needs to air dry for 24 hours before being handled. This will keep the paint from smearing. If the paint is thickly applied, drying time will be longer than 24 hours. Once the paint is dry, cover the stenciled fabric with a pressing cloth, and iron to heat set. Wash using only cold water and do not put fabric stenciled with oil paint sticks into the dryer.

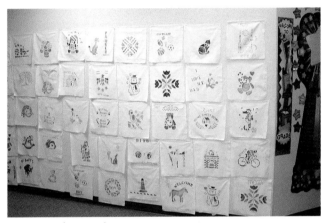

Hang stencils to air dry.

When students finish with a stencil, it needs to be cleaned. Adults can clean oil paint from stencils by gently rubbing the surface with dry paper towels. Fabric paint may also be removed from stencils with moist paper towels. **Clean brushes in a timely manner also. Use a brush cleaner to remove oil paint before it hardens.**

Stenciling With Freezer Paper and Cray-pas

A safe and easy way to make and use stencils with children is to cut stencils from freezer paper and use Cray-pas oil pastel crayons. Freezer paper is inexpensive and is easy to draw on and cut with scissors (eliminating the need for craft knives). It is also easy to iron onto and remove from fabric.

Cray-pas oil pastel sticks are available at art and crafts stores.

> Purchase freezer paper at your grocery store in the paper goods or canning sections.

1. Decide ahead of time how the stenciled blocks will be used. If they are made for a quilt or a pillow, the fabric can be cut to the final exact size plus ½" for seam allowances. If the design is going to be put into a hoop and hand quilted, cut the fabric quite a bit larger than the size of the hoop. For example, if the hoop has a 10" diameter, cut the fabric 15" square so you will have plenty of fabric for the hooping.

Wash and iron the fabric for stenciling. Cut fabric and freezer paper to the desired size. Iron the waxy side of the freezer paper to the back of the fabric. Emphasize the need to keep both hands away from the iron's hot surface. The paper backing provides stability while stenciling. Set this piece of fabric aside.

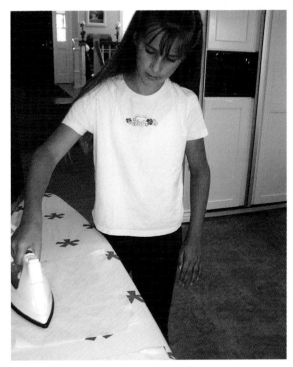

Teach children how to hold and move the iron.

2. Cut a second piece of freezer paper the same size as the fabric. Have children draw a closed-shape design (or silhouette type of design) onto the paper side of the freezer paper. The first shape to be stenciled does not have detail in it. This can be added later in the stenciling process.

Draw the design onto the freezer paper.

3. Using paper scissors, cut out the closed shape. Do not cut from the edge of the paper into the design itself; rather, poke a hole (using a pencil) into the center of the area to be cut out and start cutting from that position. Cut out only inside the drawn area.

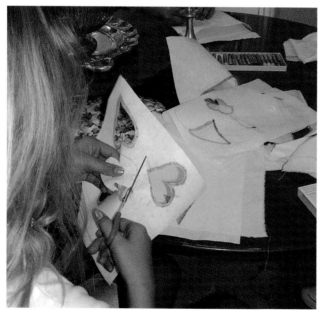

To cut, poke a hole in the center of the design.

Teach children to cut paper by holding the scissors pointed directly away from the front of their bodies at a 90° angle. They should turn the paper they are cutting—not the scissors—in order to go around curves, points, and angles. This is easier than twisting and turning their wrists and following the cutting lines by turning the scissors.

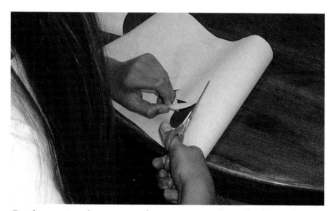

Cut by moving the paper so the scissors cut along the drawn line.

4. After the stencil shape has been cut out, iron the freezer paper (waxy side down) to the front side of the layered, stabilized fabric.

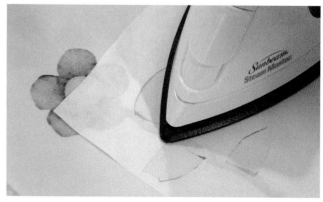

Carefully press the freezer paper over the area to be stenciled.

5. Using Cray-pas, draw a line of color on the freezer paper (not the fabric) around the cut-out area. Then wrap the pointer finger in a clean piece of fabric (such as muslin) and push the line of Cray-pas color from the freezer paper into the fabric.

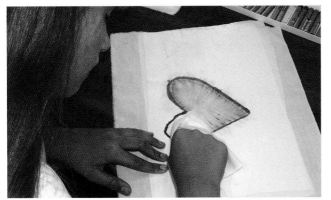

Push the color from the line of color onto the freezer paper.

Turn the stencil/fabric piece as the color is pushed off so the color is always being pushed toward the center of the design. Apply more color to the freezer paper if desired. Also, children can use more than one color, which provides texture and depth.

6. When the stenciling is complete, remove the freezer paper by gently peeling it back. You should be able to use the stencil again.

> After each stencil is finished and the freezer paper removed, iron the fabric using a pressing cloth between the iron and the stenciled fabric piece. This will further melt the Cray-pas and set the color.

7. To add detail, place freezer paper over previously stenciled areas and ironed down. In this way, you can stencil another color on top of a previous color. Additional colors can be added, and the freezer paper protects the previous color over which it is ironed. The circular flower center was accomplished in this way.

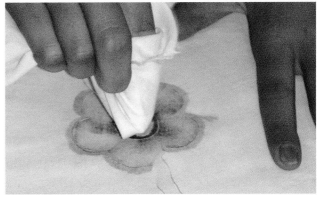

Place a small piece of freezer over an area already stenciled.

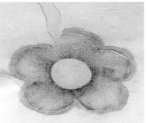

The color under the freezer paper remained blue.

The flower and stem before additional leaves are added

8. Additional details may be added by placing freezer paper (paper side up) over the already stenciled design and adding more areas to stencil. The leaves on the flower stem were added this way.

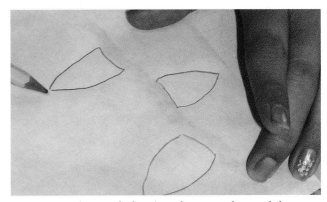

Freezer paper (waxy side down) on the previously stenciled area

9. After drawing the items to be added, cut out the drawn area from the freezer paper and iron the paper onto the fabric. Stencil as before, then remove the freezer paper.

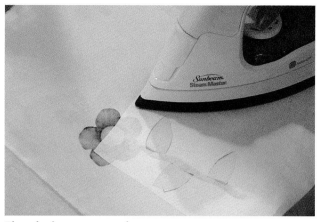

Place the freezer paper and press.

Stencil the new designs.

Gently remove the freezer paper.

10. If desired, additional stenciling may be added or the original design may be stenciled onto the fabric a second time using the same or different colors. Iron the final stenciled piece using a pressing cloth to protect the iron from Cray-pas color.

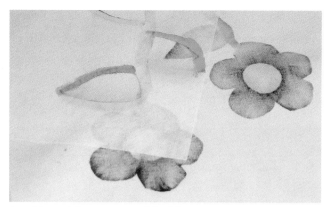

An additional flower stem with leaf design

11. Stenciled designs made this way can be used in a number of projects. A quilt can be made from the blocks after they have been trimmed and squared. Children might make their block into a pillow, or the stenciled design can be put into a hoop with batting and backing and hand quilted.

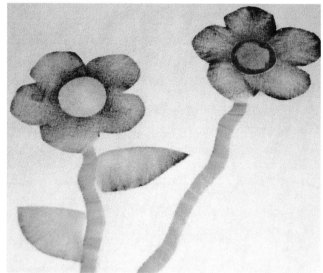

The finished flower stencil

Two finished stenciled designs

Alternative Stencil Projects

There are many project possibilities with stenciling. Students can make a pillow out of stenciled squares, or they can stencil on aprons, tote bags, and other ready-made items. To make a wallhanging, place the stenciled fabric in an embroidery hoop with batting and backing for students to hand quilt around the stenciled design. Stenciling is also a great activity when making raffle or charity quilts. Students can also stencil on paper to create cards and artwork. These are just a few of the many examples.

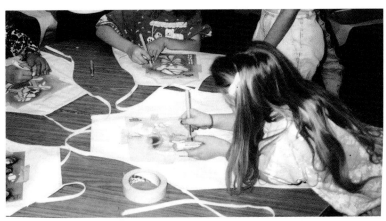

Stenciled projects are fun to make!

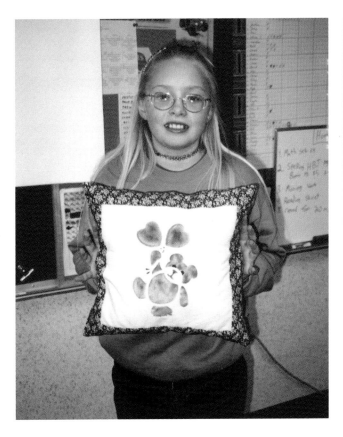

8 Photo Printing and Labels

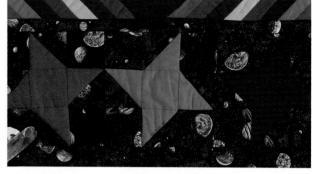

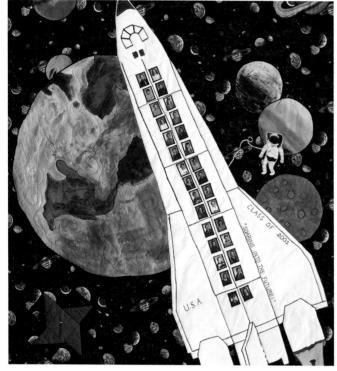

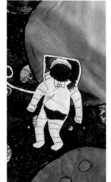

Photo Prints

Use photos printed on fabric to include photographs of the students on the quilt top or label. Photo prints also provide an additional way to include student artwork in a quilt. Blocks of printed artwork can be used to piece the quilt, or printed drawings can be cut out and appliquéd onto the quilt.

There are several methods for printing photos or drawings on fabric. Perhaps the easiest is to purchase pretreated sheets of fabric (by manufacturers such as Printed Treasures or June Tailor) that can be run through an ink jet printer. This fabric has been treated with a special finish and comes adhered to a paper backing so it can easily be run through an ink jet printer. Copy or scan the pictures that are to be printed and then manipulate them as necessary using computer software.

If you do not have access to a scanner and the necessary computer software, you can do a paste-up using all the parts you want included. Use double-sided tape or rubber cement to attach pictures, text, and graphics to a piece of paper. Take this paste-up to a copy store, some quilt stores, or a store that sells T-shirt transfers and have them transfer the image onto fabric.

Students love and get satisfaction out of sharing their quilt with family and friends. They especially enjoy pointing out their picture on the quilt! You can incorporate photographs of students into the front of the quilt in interesting ways. For example, if you use preprinted fabric of animals or people, appliqué photos of student faces to those figures. You can also add student photographs to elements of the quilt design, such as student faces looking out the windows of the space shuttle, a covered wagon, or the portholes of a ship. Use photographs of a group of students in

individual blocks (this is an especially good technique if you have a large group of students that you want to include on one quilt). You can also include photo prints of the class or of students working on the quilt project as part of the label.

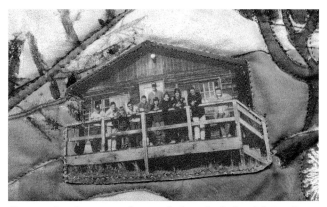

Groups of students were photographed on the decks of their cabins at the outdoor laboratory school.

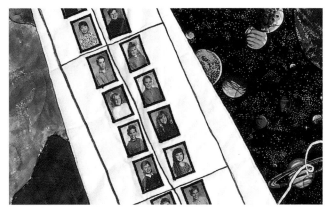

Students peer out the space shuttle windows.

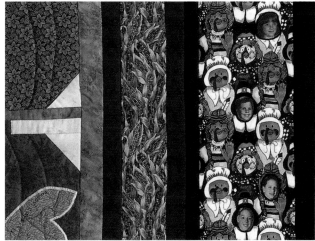

Students' photos appliquéd on the border.

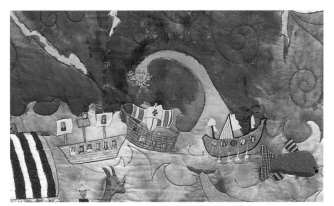

Student faces peek out of the portholes.

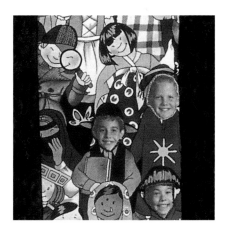

Student photos on a border.

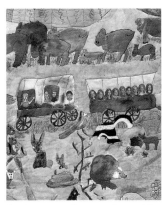

Students travel across the prairie in Conestoga wagons.

Student photographs accompany their thoughts on what it means to be American.

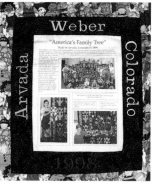

Labels with photo prints *Muslin label written with a permanent marker*

Labels

It is important to document your new quilt with a label. The label can be fancy or as plain as a piece of muslin—just as long as the quilt has one! Include on the label the name of the quilt, its size, the date, the makers, the makers' location, and any other important information. You may write labels with a permanent marker onto freezer paper-backed muslin (this gives the fabric stability), or run the freezer paper-backed fabric through an ink jet printer.

To prepare the material for a computer-printed label, iron a piece of 8½" x 11" fabric onto 8½" x 11" freezer paper or use the pretreated fabric sheet designed for ink jet printers (see page 54 and Tip above). Iron the waxy side of the paper to the back of the fabric. After printing on an ink-jet printer or writing on the label with a permanent pen, remove the freezer paper. You may then add decorative stitching or embroidery to the label. Be sure to use a lightweight tear-away stabilizer under the label when adding decorative stitching.

Using permanent pens or markers, students may also sign their names to extra blocks (the ones made as samples, for example) or to an extra-large block that replicates the blocks used on the front of the quilt. Hem the edges of these blocks and add them to the back of the quilt as additional labels. Include photo prints of students as part of the label.

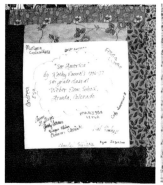

Label made using extra blocks *Extra-large blocks made into a label*

Purchased fabric also makes an interesting label. For example, American flag fabric provides white "lines" onto which students can write the quilt's history. It makes a perfect label for a patriotic quilt.

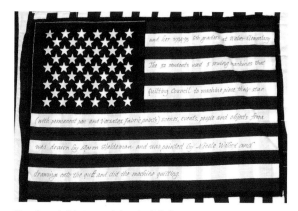

Purchased fabric used for the label

9 Machine Embroidery

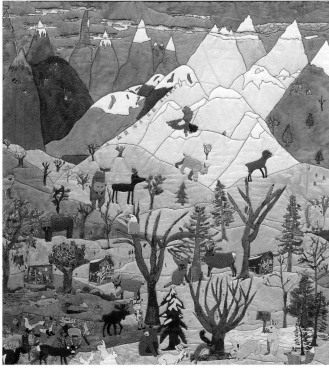

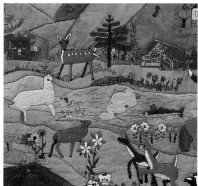

E mbroidery in quilts adds color, detail, and interest. Embroidery/sewing machines have become readily available to the home sewer. Consider using embroidery software (available from many sewing machine manufacturers) to transform drawings by children into embroidery designs through a process called "digitizing."

Embroidery software is available that can digitize the drawings. Software is also available that automatically digitizes a drawing, but read the instructions carefully to see how the drawings should be prepared before scanning them.

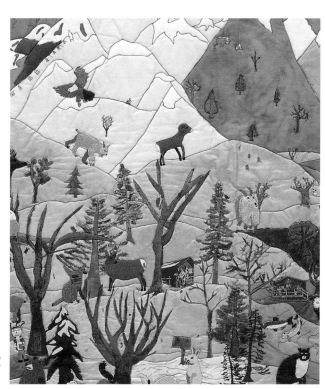

Student drawings as embroideries add interest and color to a quilt.

Six of the seventeen Weber School quilts include machine embroidery digitized from drawings by the students. For the software to "read" the bitmap (.bmp) images, the drawings need to be crisp and clean. Students draw their original artwork in pencil, then trace over the pencil lines using a fine-tipped permanent marker. Then they erase the pencil lines and color the drawing with crayons or markers. (The drawings were scanned at 100 dpi and saved as .bmp files.)

Student drawings and the stitched versions

In making *Colorado: The Great Outdoors* (page 23), students digitized their own drawings (with the help of an adult). After opening their drawing in the digitizing software, decisions need to be made about which area to digitize first. The process is similar to ordering layers in an appliqué design. The first areas digitized are the areas "furthest back" or underneath. Make a list after determining the order of layered areas, including the color of each layer. As each section is done, students can choose the fill pattern (texture) and the angle of the design.

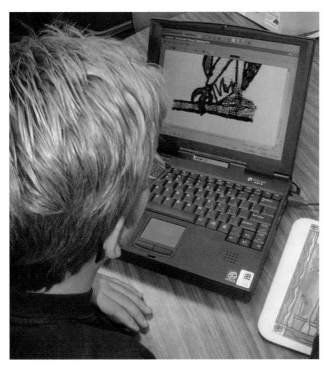

Using digitizing software

Scanned drawing of an owl The embroidered owl

It takes time to digitize with students because it requires working one-on-one. Students enjoy the attention as well as the amazing process of seeing their drawings become dimensional and textured. They become more aware of the technology available, and gain an appreciation for the work that goes into this process.

Working with the software is fun!

It is important to use stabilizer in your embroidery hoop when embroidering on a quilt top. Stabilizer adds stability to the fabric and allows the embroidery to register correctly and stitch out accurately. A medium-weight tear-away stabilizer works well on a quilt top. It is stiff enough to provide good stability, and students can easily tear away the excess after the embroidery is stitched out.

It is also important to "stitch out" each design in order to check for changes that need to be made before the design is stitched onto the quilt top. At the end of the project, students can be given the stitch-outs as a remembrance of the project.

Students enjoy seeing the stitch-outs of their designs.

As much fun as the digitizing is, the actual embroidery process is magical for the students. Using computer embroidery software, some of the objects in *Colorado: The Great Outdoors* (page 23) were resized and then several were grouped together to make a "family."

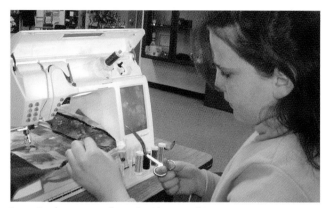

Flower designs were grouped together to make "families" of flowers.

A woodpecker resized from 4" to ¾".

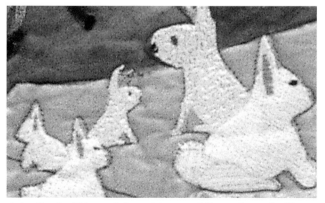

A family of rabbits made by resizing two different digitized rabbits.

Students easily learn to thread and use the machine. Using their drawing and notes as a guide, students choose their thread colors and the placement on the quilt for their embroidery.

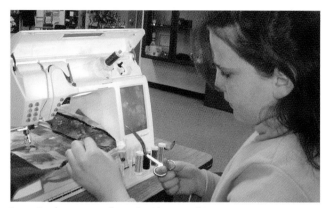

Learning how to use the embroidery machine

Boys and girls alike enjoy the process of machine embroidery. Watching the quilt come alive with the addition of each embroidery provides daily excitement.

Everyone loves these machines!

If the design to be embroidered is closer to one side of the quilt top, try hooping the quilt top upside down or sideways so the bulk is to the left and not under the arm of the sewing machine.

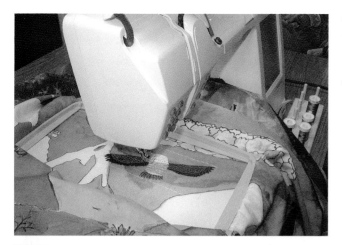

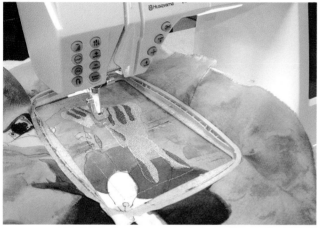

Hoop the quilt top.

When the embroidery is done, show the children how to carefully remove the tear-away stabilizer.

Removing the stabilizer from the back of the design

One of the students involved in making *Colorado: The Great Outdoors* was blind. Using a stuffed animal to touch and with a little bit of help, he was able to draw a picture of an elk.

Drawing by a visually impaired student

This very perceptive student was the only student (out of the 96 involved) to comment on the fact that the hoop moved back and forth as well as side to side.

Touching the quilt allowed him to "see" the other animals made by his fellow classmates.

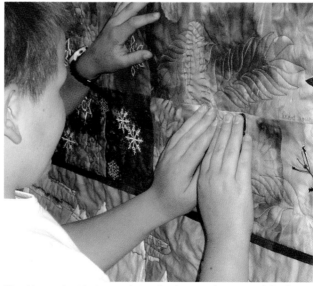

Touching embroideries can bring the shape and texture of the design to life.

Machine Embroidery **61**

Be creative in adding embroideries to a quilt top! Embroider on top of painted scenes or animals, or paint some of the animals in a group and embroider other animals around or on top of them.

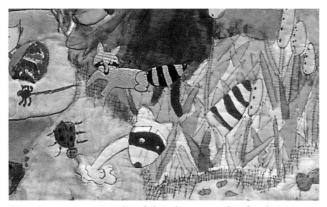

One raccoon was painted and the other was embroidered near it.

Add decorative or straight stitching to embroideries. One student created a spider web by using a triple straight stitch and then embroidered his spider and fly on top of it.

Spider web

Try combining the embroidery of several students to make a new composition. In *It's a Pond's Life* (page 20), seaweed and fish designed by two students were combined into one embroidery design.

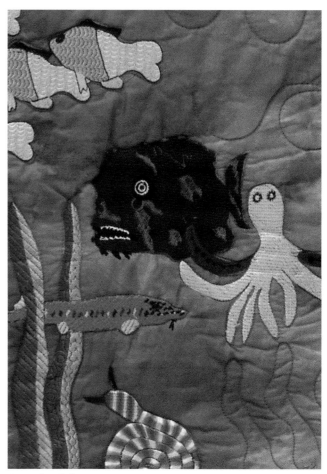

A combined design

A word of caution: Carefully read the licensing information on any commercial, purchased, or even free Internet designs regarding their use. If you are making a quilt to sell (such as a raffle quilt), you cannot use licensed designs without consent.

Projects

Kindergarten Quilt

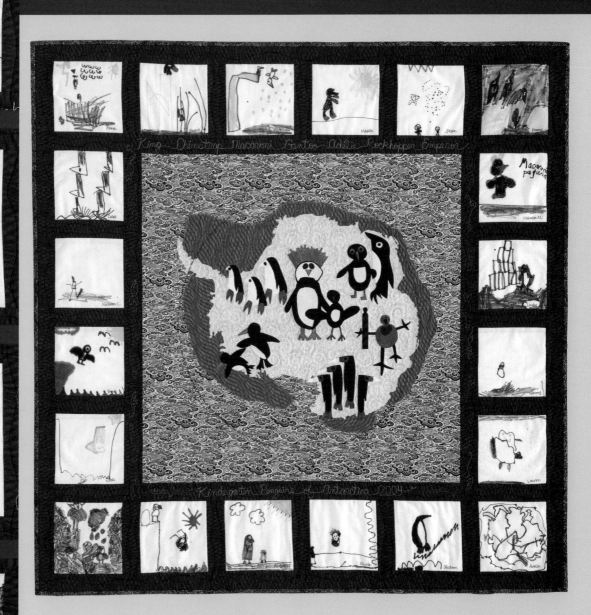

KINDERGARTEN PENGUINS OF ANTARCTICA

50″ x 50″, made by Barbara Bogner's 2003–2004
kindergarten class with Amy Hodgson Mundinger
at Foothill Elementary School, Boulder, CO

Quilt Design

Ms. Bogner's morning kindergarten class was studying Antarctica. Each student designed his or her own penguin block. Additional student drawings of penguins were selected and appliquéd onto the center panel, which represents the continent of Antarctica, its ice shelf, and the Antarctic Circle.

This quilt design lends itself to many subjects. Have the center of the quilt show the main idea of a topic, such as a country or state, a favorite book, a part of speech, an object, an historic event, or a famous person. The surrounding blocks then provide details about the main theme.

Time Requirements

☐ Time for students to research the topic, either in the classroom or during library time

☐ 30–60 minutes for students to draw designs onto fabric squares using fabric markers

Cutting Instructions

Blue 1: Cut a 30½" x 30½" square for center panel.

Cut 2 pieces 55" x width of fabric for backing.

White: Cut 4 strips 6½" wide x width of fabric and cut into 20 squares 6½" x 6½" for blocks.

Medium-dark blue: Cut 2 lengthwise strips 2½" x 34", 4 lengthwise strips 2½" x 50", and 2 lengthwise strips 2½" x 54" for inner and outer borders. (These will be trimmed to the exact length later.)

From the remaining fabric, cut 16 strips 2½" x 6½" for sashing.

Dark blue: Cut 5 strips 2¼" wide x width of fabric for double-fold straight grain binding.

Cut 2 strips 9" wide x width of fabric. Piece end to end and cut a strip 9" x 50" for the hanging sleeve.

Fabric and Notions Requirements

Includes enough materials for approximately 20 students, plus extra block fabric for students who might want to start over.

☐ 4 yards blue fabric 1 for center panel and backing

☐ 1 yard blue fabric 2 (contrasting with center panel) for ice shelf

☐ 1½ yards medium-dark blue fabric for sashing and borders

☐ 1 yard dark blue fabric for 4" hanging sleeve and binding

☐ ¾ yard white/off-white fabric for Antarctica continent appliqué

☐ 1 yard white cotton for blocks

☐ ¼ yard solid black fabric for appliquéd penguins in center panel

☐ Scraps of white, red, and orange for appliquéd penguins

☐ 3 yards paper-backed fusible web

☐ Batting: 55" x 55"

☐ 50-weight medium gray thread for piecing

☐ 40-weight rayon embroidery thread and 60- to 70-weight bobbin thread for appliqué

☐ Teflon pressing sheet

☐ Freezer paper

☐ Fine or medium-tipped fabric markers

☐ Black fine-point permanent marker

☐ Rotary cutter, ruler, and mat

Preparation

1. Iron freezer paper to 6½" blocks of white cotton.

2. Using a rotary ruler, draw faint pencil lines slightly less than ¼" from the edges to indicate where the seams will be.

3. Instruct students about the quilt's theme. Ask them to use fabric markers to draw their penguins on the fabric within the pencil lines. Interested students can use paper markers to draw additional penguins on white paper to be used as appliqué patterns in the center panel.

Penguins drawn on freezer paper-backed muslin.

4. Remove the freezer paper backing from the muslin squares, and set the fabric markers with a hot dry iron as directed on the fabric marker package.

5. Make a black-and-white photocopy of a map of Antarctica and the ice shelf using a regular photocopy machine. Enlarge the copy either by using a blueprint enlargement machine (see page 35) or by making a transparency and using an overhead projector (see page 36). Enlarge the map to a finished size of no more than 24" square.

6. If using a full-size photocopy, tape fusible web to the back of the copied map with the glue side of the web toward the paper. To make the web wide enough, you may need to overlap 2 pieces of web and tape them together on the paper side. If using an overhead projector, place the transparency upside down on the projector and project the image onto the paper backing of fusible web that has been overlapped as needed and taped to the wall. This will project a reversed image of the continent onto the fusible web. For either method, after the web is ironed onto the continent fabric and cut out, the map will be right side up.

7. Trace the reverse image of the continent on the paper side of the fusible web with a pencil or pen. Iron the fusible web to the back of the white/off-white fabric. **Be sure to remove the tape before ironing!** Cut out the shape.

8. Also trace the ice shelf (in reverse) on the paper side of fusible web. Iron the web to the back of the blue fabric 2. Cut out the shape, adding ⅛" along the edges that will be under the edge of the continent.

9. Remove the paper backing from the continent and the ice shelf. Place the continent on the center background fabric. Before pressing, lay the ice shelf in place by inserting it ⅛" under the edges of the continent. Then fuse following the manufacturer's instructions.

10. Use a light table to trace the students' paper drawings of penguins onto fusible web. Place the drawing upside down on the table and, with the glue side of the web toward the drawing, trace on the paper side of the web. Trace each part of the penguin separately and add about ⅛" to the sides that will be overlapped by another part. Iron the webbing to the wrong side of fabrics that match the colors in the original drawings, and cut out the parts.

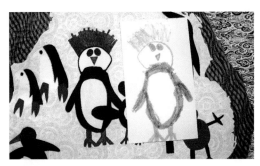

Student drawings of penguins are patterns for the fused appliqués.

11. Remove the paper backing from the penguin parts and assemble the penguins on a Teflon pressing sheet. Fuse the parts together on top of the pressing sheet. When the penguins are cool, remove them from the pressing sheet and have students arrange them on the continent of Antarctica. Fuse the penguins to the background, and machine satin stitch or free-motion straight stitch around the raw edges using 40-weight rayon thread.

Quilt Assembly

To trim borders to the correct size, see Steps 2 and 3, Tips for Piecing, p. 82.

1. Trim the 2½" x 34" border strips to fit, and sew to the top and bottom of the center panel; press. Piece together the top and bottom rows, each containing 3 vertical sashing strips and 4 blocks; press. Attach 1 row to the top of the center panel and the other row to the bottom; press.

2. Trim 2 of the 2½" x 50" border strips to fit and sew to the sides of the quilt; press. Piece together the side panels, each containing 6 student blocks and 5 sashing strips; press. Add these 2 panels to each side of the quilt center; press.

3. Trim 2 of the 2½" x 50" border strips to fit and sew to the top and bottom of the quilt; press. Trim the 2½" x 54" border strips to fit and sew to the sides of the quilt; press.

Layout for Kindergarten Penguins of Antarctica

Finishing

1. Sew backing pieces together and trim to make the backing 55" wide x 55" long. Layer the backing, batting, and quilt top.

2. Hand or machine quilt (see Quilting the Quilt, page 83). Quilting motifs in this quilt include the names of penguins from Antarctica as well as the name of the class who made the quilt.

Quilting detail

3. Bind and add a 4" finished sleeve on the back for easy hanging (see Attaching the Binding and Sleeve, page 84).

4. Label your quilt with the class name, teacher, school, and date. Include a short history of the quilt, along with a photo of the students with the quilt, as part of the label.

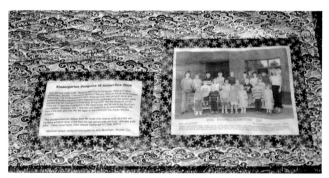

Kindergarten Penguins of Antarctica *label*

Pattern Block Quilt: Math Lesson in Symmetry

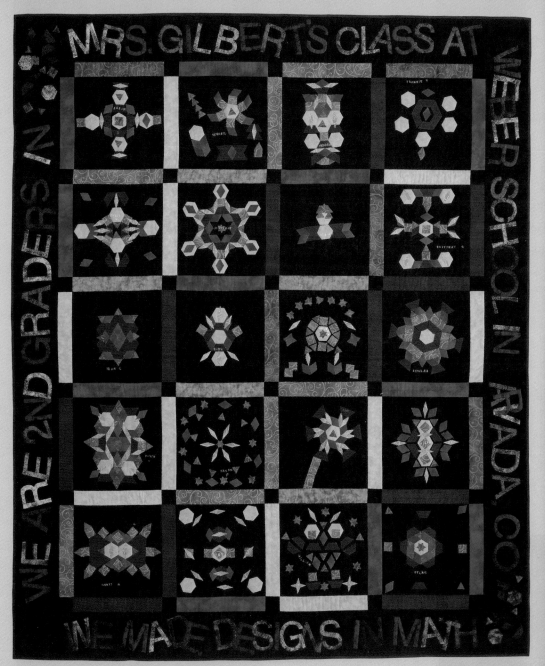

DESIGNS IN MATH: 2ND GRADE STYLE

70″ x 84″, made by Sue Gilbert's 2003–2004
2nd grade class with Kathy Emmel at Weber
Elementary School, Arvada, CO, 2004. Quilted
by Sandi Fruehling.

Designing the Quilt

This quilt was based on the math concept of symmetry that students studied in first and second grade. Students used pattern blocks, a math manipulative, to create symmetrical designs. Students made sure the color, shape, and number of pieces used demonstrated their understanding of symmetry.

One of the first considerations in designing this quilt was determining how many students would be taking part in the project. In this instance, there were twenty students in this class. After considering several different layouts, we chose a 4 x 5 block layout.

Graph paper is easy to use for drawing the quilt design. For this quilt, ¼" on the graph paper equaled 2" on the quilt block. If you are comfortable with software such as Adobe Illustrator or CorelDraw, this is another way to plan the quilt. An additional method is to use a quilt design program such as Electric Quilt 5, which will print out rotary cutting instructions and fabric requirements.

Hand-drawn layout on graph paper

Computer-drawn layout using Adobe Illustrator

Layout created using Electric Quilt 5

Time Requirements

In preparation for this quilt, ask volunteer parents to cut one 12" square of black construction paper for each child, as well as many pattern block shapes from red, yellow, orange, green, blue, and cream construction paper. They need to cut approximately 6–10 yellow hexagons, 6–10 red trapezoids, 10–18 blue diamonds, 10–18 green triangles, 4–10 orange squares, and 4–10 cream small diamonds for each child, plus extras of each color piece. On the front of the black 12" squares, volunteers need to draw a white line 1" in from each edge, mark the center of the square, and write the child's name at the bottom edge of the paper.

Precut background and paper pattern pieces

Time at home: Parents trace and cut pattern block pieces from prepared fabric.

Time at school:

☐ 90–120 minutes: Students make paper mock-ups of the symmetry block at school during a math lesson

☐ Three 3-hour sessions for students to lay out pattern block pieces and fuse them to black fabric square (one adult working with 3 or 4 students at a time)

☐ One 5-hour session for stamping names and borders

Fabric and Notions Requirements

Includes enough materials for approximately 20 students, plus extra fabric for blocks and pattern pieces for students who might want to start over. **The most important part of the project is that each child is happy with his or her block.**

☐ 5½ yards black fabric for blocks and borders (cut lengthwise)

☐ 1⅜ yards each of blue, green, yellow, cream, and orange fabric (batik fabric is recommended) for sashing and pattern block pieces (If using a die-cut machine to cut the pattern block pieces, more fabric will be required.)

☐ 2 yards red fabric for pattern block pieces, sashing, and binding (batik fabric is recommended)

☐ 5½ yards fabric for backing and hanging sleeve

☐ 12 yards paper-backed fusible web, such as Pellon lightweight Wonder-Under

☐ Batting: 75″ x 89″ (We used Hobbs Heirloom batting so quilting stitches could be as much as 3″ apart.)

☐ Clear monofilament thread

☐ Medium gray 60- or 70-weight bobbin thread for appliqué

☐ Black (50 wt) cotton thread for piecing

☐ Template plastic

☐ Large alphabet stamps (or compressed sponge material for cutting any size and shape letters and numbers; in this quilt, the letters were 3½″ high)

☐ Small stamps for stamping names on blocks

☐ Acrylic or opaque fabric paints (such as Liquitex or Golden): white, red, blue, green, yellow, and orange

☐ Textile medium for mixing with acrylic paints

☐ 1″ brushes for mixing paint and textile medium

☐ Foam plates for paint palettes

☐ Black, blue, green, yellow, red, cream, and orange construction paper to match the colors of pattern blocks and for the background squares

☐ Ellison die-cut machine (optional)

☐ Glue (such as Elmer's)

☐ Butcher paper

☐ Plastic to cover tables

☐ ¼″ removable masking tape (optional)

☐ Small plastic bags for pattern block pieces

☐ 2 buckets of water for rinsing out sponges and brushes

> **Tight-weave fabrics, such as batiks, work well for the pattern block fabric pieces because they usually don't unravel as easily.**

Preparing the Fabric

1. Choose fabrics that match the colors of the pattern block pieces.

2. Iron fusible web to the back of 1 yard of each color fabric.

3. Trace the pattern block shapes on page 76 onto template material and cut out. See the tip on page 70 for the number of templates you will need to cut.

Send these pieces of fabric, along with plastic pattern block templates, home to parents. Also send instructions on how to cut out the pattern block pieces using templates and scissors. They will need to cut approximately 6–10 yellow hexagons, 6–10 red trapezoids, 10–18 blue diamonds, 10–18 green triangles, 4–10 orange squares, and 4–10 cream small diamonds for each child, plus some extras of each piece.

> We sent one of each template and ¼ yard of each of 6 colors home to 4 parents. An alternative idea is to send one yard of just one color and one template home to each parent (6 parents total).

Pattern piece preparation

Sample die-cuts

If you have an Ellison die-cut machine at school, this may make it easier to cut out the pieces. These machines have dies that can cut paper, as well as fabric ironed to fusible web. It works well, but there is more fabric waste than in drawing and cutting pieces individually. You will need to precut the web-backed fabric into smaller pieces to fit the machine.

4. Organize the fabric pieces by color and place them in plastic bags.

Cutting Instructions

Black: Cut 2 lengthwise strips 6½" x 62" and 2 lengthwise strips 6½" x 88" for borders. (These will be trimmed to the exact length later.)

From the remaining fabric, cut 20 squares 12½" x 12½" for the blocks and cut 30 squares 2½" x 2½" for corner squares.

Blue, red, green, yellow, orange: From the fabric that is not backed by fusible web, cut 4 strips 2½" x width of the fabric from each of the 5 different colors and cut into 10 strips 2½" x 12½" of each color for sashing. You will use only 49 of the 50 strips.

Red: From the fabric that is not backed by fusible web, cut 8 strips 2¼" x width of the fabric for binding.

Backing: Cut 2 pieces 89" x width of the fabric.

Hanging sleeve: Cut 2 strips 9" x width of the fabric. Piece end to end and cut 1 strip 9" x 70".

Paper Practice Block

Before making the quilt block, have each student make a practice block from construction paper. The colors of the pieces and the size match those of actual

pattern blocks. Check student designs for symmetry before they glue the pieces onto the background paper. Double-check to make sure students do not extend their design into the 1" border. Hang the completed paper blocks to the wall for students to see the quilt in its infancy.

Creating symmetrical designs on paper

> When gluing down the bright
> pieces, it may be easier for
> students to lift each pattern piece
> one at a time, put a drop of glue
> on the black background paper,
> and then set the pattern piece on
> the glue instead of applying glue
> to the small pattern pieces.

Classroom Setup and Block Creation

1. Set up an ironing center with pressing pads (see page 26).

2. Have students use their construction paper blocks as a guide to count out the fabric pieces needed for their designs.

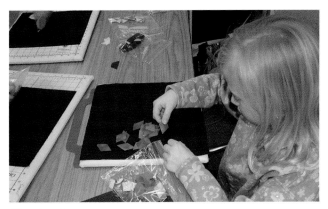

Choosing pieces

3. Show students how to fold and finger-press the 12½" square of black fabric in half once and then in half again to find the center. This way they can build their design from the center out (ensuring that the entire design will fit onto the fabric square).

> An optional method to help
> students visualize the work area on
> the fabric is to use ¼" removable
> masking tape to outline an 11"
> square within the 12½" black back-
> ground square. Do not remove the
> tape until after the pieces are
> ironed down, but be sure not to
> touch the iron to the tape.

4. Show students how to remove the paper backing from the fabric pieces by creasing a corner of the paper away from the fabric to loosen it. Have them refer to their paper mock-up to place the fabric pieces on the black fabric square.

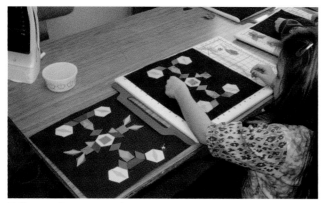

Following the paper mock-ups

5. After some of the center pieces are laid out, attach them by pressing with a dry iron, holding the iron on the block for 5 seconds. Students enjoy holding the iron down (with an adult's help or supervision) and counting to 5.

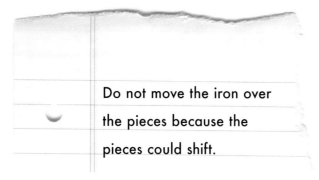

Do not move the iron over the pieces because the pieces could shift.

6. Continue building the design toward the edges, but be careful to leave a ½" to 1" seam allowance. When the design is completed, fuse all pieces to the background square following the manufacturer's instructions. Note that some students may change their designs as they work. Watch to make sure the design remains symmetrical and does not extend into the border.

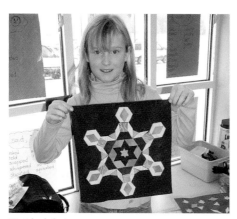

Finished design

7. Display the blocks on the wall as they are finished until you are ready to stamp names onto the blocks using acrylic paint.

Stamping

There are many commercial alphabet stamps and sponges available at craft and scrapbooking stores, or you can make your own from sheets of compressed sponge.

Commercial stamp sets

Compressed sponge

1. Choose a font on your computer and type the alphabet and a set of numbers 0 through 9. Apply the outline format to the characters.

2. Increase the letters to the size you want for your sponge letters.

3. Print out the characters, cut them out, and trace them onto the sponge material.

4. Use sharp scissors to cut out the shapes.

Print letters and numbers in outline form.

stamping names on the blocks

1. Mix white acrylic paint with textile medium (at a ratio of 2:1). Place a small amount of paint on a foam plate.

2. Provide stamps of ¼"-high letters for students to stamp their names on their blocks. Demonstrate how to gently touch each stamp (one at a time) to the white acrylic paint on the foam plate to apply the paint to the stamp. The paint should only be on the raised letter section of the stamp. If this is difficult for the students to do, have them use a brush to apply the paint to the raised part of the stamp. Allow students to practice stamping their name on a piece of fabric before stamping on the actual block. Help them decide where they want to stamp their name on their block.

Small stamp sets are great for names.

Using ¼" stamps to print names

Be sure the paint is smooth and doesn't clump onto the stamp. Encourage students not to press down hard while touching the stamp to the paint; otherwise, the stamp will pick up too much paint and will not leave a clear impression of the letter.

3. After each stamp is used, clean it with a wet paper towel or baby wipes.

stamping the border strips

1. On a white piece of paper the same size as the border, create a guide for students by writing the words to be stamped.

2. Place the precut border strip and the white paper side by side on top of a long sheet of plastic. The plastic protects the table from any paint that might bleed through the fabric.

3. Have students immerse the compressed sponge in a small container of clean water to expand it. Students love this step!

Sponge expansion: a high point of the day!

4. Mix acrylic paint with textile medium (2:1) on foam plates. Use a separate plate for each color of paint. Be sure there is enough paint for students to get good coverage on the sponges. Don't be stingy! Acrylic paint is opaque, but if there is not enough of it on the sponge, the letters come out too light on the dark background.

Using a paper pattern as a guide

If the paint is too light, restamp the letters by carefully repositioning the sponge on top of the original letter.

5. Have students clean each stamp immediately after it is used. Make sure students rinse out the sponges by squeezing, not twisting. Otherwise the sponge will rip. Also, make sure the water is entirely squeezed out; too much liquid left in the sponge dilutes the paint when the next student presses the sponge on the fabric.

Provide a large bucket of water near the work area so students can rinse paint out of the sponges as they use them.

6. After each border is stamped, hang it on the wall to dry. Because the paint was mixed with textile medium rather than water, the paint should dry fairly fast, while retaining a thick consistency.

7. Iron all borders before piecing the quilt top.

Quilt Assembly

1. To make the pattern block pieces permanent, sew them to the background blocks using a straight stitch. Use monofilament invisible thread on the top of the block and a neutral color (such as gray) 60 wt thread in the bobbin. Monofilament thread allows you to sew from one color piece to another without having to change the thread.

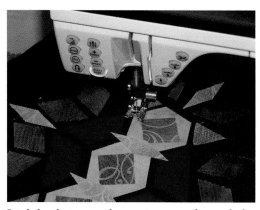

Stitch fused pieces so they are permanently attached.

2. Use black thread to assemble the quilt blocks in rows. Make 5 rows, each containing 5 vertical sashing strips and 4 blocks 12½" x 12½". Press the seams toward the center of the sashing strips.

Press seams toward center of sashing strips.

3. Assemble the 6 joining sashing rows, each with 4 sashing strips and 5 black corner squares. Press the seams toward the sashing strips to allow seams to butt together as the rows are joined. Make 6 rows for horizontal joining strips.

Press seams toward sashing.

4. Sew the rows together; press.

5. To trim borders to the correct size, see Steps 2 and 3, Tips for Piecing, page 82. Add the top and bottom borders, press.

6. Add the side borders; press.

Layout for Designs in Math: 2nd Grade Style

Finishing

1. Sew backing pieces together and trim to make the backing 75" wide x 89" long. Layer the backing, batting, and quilt top.

2. Hand or machine quilt (see Quilting the Quilt, page 83). Because the pattern block design and letters are so busy, the quilting design is simple. Stitch in-the-ditch between all blocks, sashing, and borders. Free-motion machine quilt in and around the designs and lettering.

3. Bind and add a 4" finished sleeve on the back for easy hanging (see Attaching the Binding and Sleeve, page 84).

4. Label your quilt with the class name, teacher, school, and date. Include a short history of the quilt, along with a photo of the students with the quilt, as part of the label.

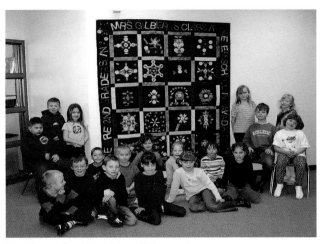

Proud second graders show off their quilt.

Quilt label

Extension Projects

This pattern block design can be made using other methods. Consider stamping the design onto the fabric using pattern block-shaped sponges. Alter the background fabric colors. Use fusible web-backed fabric pieces of any shape or use fused tangram shapes for other design possibilities.

Use pattern block-shaped sponges for a similar effect.

Pattern Block Pieces

Blue diamond

Red trapezoid

Cream small diamond

Orange square

Yellow hexagon

Green triangle

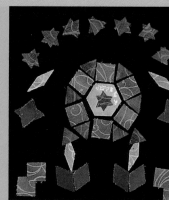

Alaska Quilt

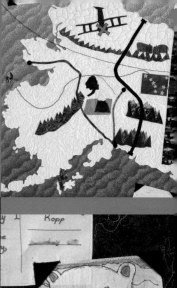

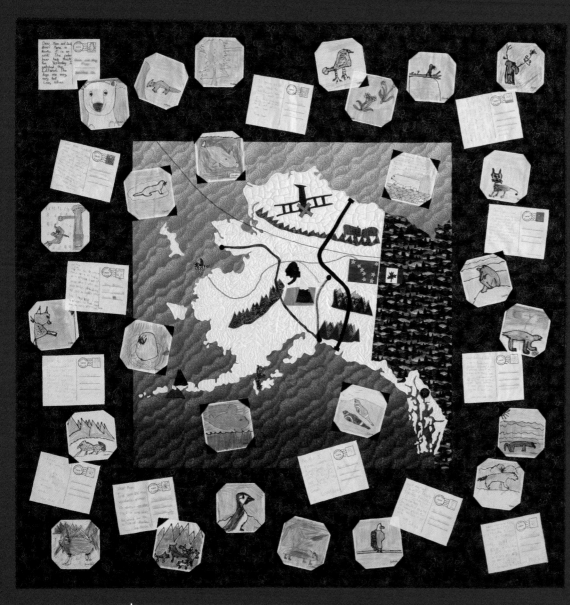

MS. HENNEMAN'S AWESOME ALASKAN ADVENTURE
70" x 70", made by Charlotte Henneman's 2003-2004
2nd grade class with Amy Hodgson Mundinger at
Foothill Elementary School, Boulder, CO

Quilt Design

Each student designed a block representing the animal that he or she studied for a research report on Alaska. Each student also added a significant feature to the appliqué map of Alaska in the center panel. In addition, some students contributed postcards written to their parents about their Alaskan adventure. These postcards were scanned and printed on photo fabric using an ink jet printer.

This quilt design lends itself to many subjects. Have the center of the quilt show the main idea of a topic, such as a country or state, a favorite book, a part of speech, an object, a historic event, or a famous person. The surrounding blocks then provide details about the main theme.

Time Requirements

☐ Time for students to research their topic, either in class or during library time

☐ Time for students to make one or more drawings of their animals

☐ Time for students to discuss which features to include in the center map of Alaska and how to lay it out

☐ 30–60 minutes for students to transfer their drawings onto fabric

☐ 30–60 minutes for students to write a rough draft and final copy of their postcards

Fabric and Notions Requirements

Includes enough materials for approximately 30 students, plus extra block and postcard fabric for students who might want to start over.

☐ 1¼ yards watery blue print for center panel

☐ 1 yard white/off-white fabric for Alaska appliqué

☐ 3¾ yards green fabric for borders, hanging sleeve, and binding

☐ 1 yard solid white fabric (use a tight weave, such as Southern Belle by Springmaid) for blocks

☐ ½ yard green tree fabric for Canada appliqué

☐ ¼ yard black fabric for "photo corners"

☐ Scraps of a variety of prints for appliquéd map details

☐ 4¼ yards backing

☐ 4 yards paper-backed fusible web

☐ Batting: 75" x 75"

☐ 50 wt thread to match border fabric for piecing

☐ 40 wt thread to match appliqués or monofilament thread for appliqué

☐ 60 to 70 wt bobbin thread for appliqué

☐ Photo printing fabric sheets (such as June Tailor Colorfast Printer or Printed Treasure Fabric Sheets) for the ink jet printer (approximately 1 sheet for every 2 postcards)

☐ Freezer paper

☐ 5" squares white paper (1 per student)

☐ Black, thin-tipped permanent pens (such as Pilot pens)

☐ Regular crayons

Cutting Instructions

Watery blue: Cut a 40½" x 40½" square for the center panel.

White/off-white: Cut strips 5" wide x width of fabric and then cut into squares 5" x 5" (1 for each student).

Green: Cut a lengthwise strip 9" x 68" for the sleeve.

Cut 2 lengthwise strips 15½" x 74" and 2 lengthwise strips 15½" x 44" for border. (These will be trimmed to the exact length later.)

Cut 5 strips 2¼" wide x width of fabric for the double-fold straight grain binding.

Black: Cut 4 strips 1¼" wide x width of fabric and then cut into approximately 120 squares 1¼" x 1¼" (4 for each picture block).

Backing: Cut 2 pieces 75" x width of fabric.

Freezer paper: Cut 1 square 5" x 5" for each student.

Preparation

1. Have students research their animals and draw them on the 5" squares of white paper. If students draw on more than one piece of paper, have them pick their favorite to be included on the final quilt. Students then outline their pencil drawing with a fine-tipped black permanent pen.

2. Iron the 5" blocks of white fabric to the waxy side of the 5" squares of freezer paper.

3. Tape each student's drawing to the paper side of the freezer-paper backed blocks. Have students use a light table and a fine-tipped permanent marker to trace their drawings onto the fabric squares. Then have them color their block using regular crayons.

4. After coloring, remove the drawing and the freezer paper. Iron the blocks to set the color.

Have students sign their blocks (but not too far into the corners) with the permanent pen.

Students' blocks

5. Enlarge a map of Alaska and Canada to a finished size of no more than 30" square either by using a blueprint enlargement machine (see page 35) or by making a transparency and using an overhead projector (see page 36). Use a proportion wheel to determine the exact percentage of enlargement.

6. Overlap the pieces of fusible web and tape together on the paper side to make it wide enough. Trace the reversed images of Alaska and Canada individually onto the paper side of the fusible web. Be sure to add about ⅛" to the side of Canada that will be overlapped by Alaska. Iron the glue side of the web to the wrong side of the white fabric for Alaska and green tree fabric for Canada (see Step 6, page 65). **Be sure to remove the tape before ironing!**

7. Cut out the shapes. Remove the paper backing, and place the shapes on the watery blue fabric. Fuse following the manufacturer's instructions. With colored or monofilament invisible thread, straight stitch around the perimeter of both shapes to permanently attach them to the background fabric.

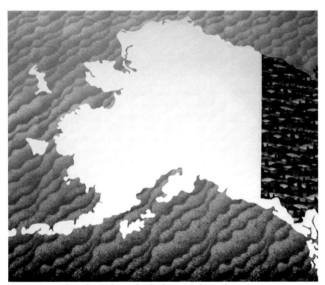

Center panel with appliquéd Alaska and Canada

8. Have students trace reverse images of their paper drawings of land features onto the paper backing of fusible web. Iron the web to the wrong side of the appropriate fabrics and cut out the features.

Students did the preliminary features work on a paper drawing of Alaska.

9. Remove the backing of the fusible web and fuse the features to the center panel following the manufacturer's instructions. Stitch around the perimeter of each object to permanently adhere it to the quilt.

10. For the "postcards," give each student a piece of white paper with the outline of a postcard (approximately 4" x 6") drawn on it. Have students write their letter to their parents and design a stamp. Scan and print on an ink jet printer or photocopy the postcards onto photo fabric (see Chapter 8, page 54). Iron the fabric to fusible web.

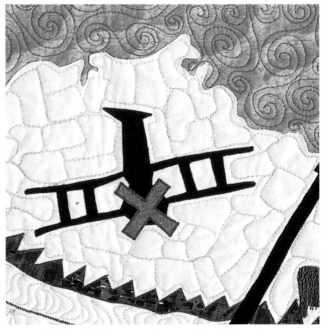

Students' designs were interpreted in fabric and fused onto the center panel.

Quilt Assembly

1. To trim borders to the correct size see Steps 2 and 3, Tips for Piecing, page 82. Trim the 15½" x 44" border strips to fit and sew to each side of the center panel; press. Trim the 15½" x 74" border strips to fit and sew to the top and bottom of the quilt; press.

2. Remove the paper backing from the blocks and postcards. Arrange them on the border of the quilt and fuse in place.

3. Using monofilament thread or thread to match the blocks, sew a straight stitch, a zigzag stitch, or a satin stitch to permanently appliqué the blocks to the quilt top.

4. To make the "photo corners," fold each 1¼" x 1¼" black square on the diagonal to make a triangle and press. Making sure the raw edges match the edges of the block, place a triangle in each corner of a picture block. Pin and sew the 2 short sides with an appliqué stitch using black thread.

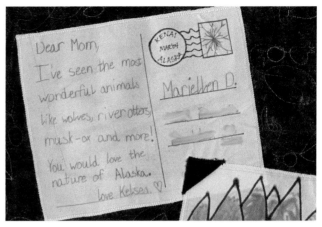

Postcards transferred to fabric and appliquéd to the quilt top.

Finishing

1. Sew backing pieces together and trim to make the backing 75" wide x 75" long. Layer the backing, batting, and quilt top.

2. Hand or machine quilt (see Quilting the Quilt, page 83).

3. Bind and add a 4" finished sleeve on the back for easy hanging (see Attaching the Binding and Sleeve, page 84).

4. Label your quilt with the class name, teacher, school, and date.

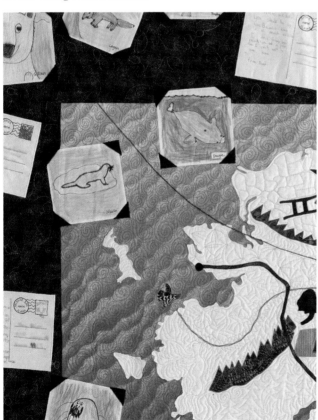

Black triangles added to the corners of student blocks resemble a photo album.

Piecing and Binding

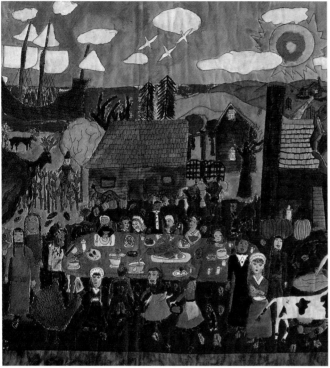

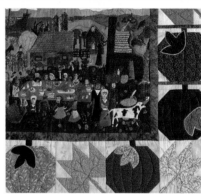

T he most crucial step that will make a huge difference in the squareness of the quilt top and how straight it will hang is the preparation of the fabric and blocks. How you cut fabric for the blocks and borders, and the accuracy of the seam allowance, are critical for a good result.

Piecing

Several techniques will make piecing the quilt top easier and more exact.

1. If children are piecing together blocks (by hand or machine), precut the pieces using a rotary cutter. For hand piecing, draw the sewing lines on the fabric. For machine piecing, have children practice sewing a ¼" seam allowance (page 32).

2. If necessary, have either the child (or yourself) re-piece a section of a child's block that is not square. Re-piece by hand or machine depending on the original piecing method. Blocks need to be as uniform and as square as possible in order for the quilt top to be pieced together accurately.

If the children's blocks are solid fabric (as in *Designs in Math: 2nd Grade Style*, page 67), precut all the blocks exactly to size.

Tips for Piecing

1. Piece the quilt blocks and borders using a ¼" seam. Press the seams to one side as the top is pieced.

2. Measure for the top and bottom borders by measuring through the center of the quilt top horizontally and then compare that to the measurement at the top and bottom of the quilt top. Make sure that the top

or bottom are within ½" of the center measurement. Cut the borders the same length as the horizontal measurement through the middle of the quilt.

3. Using pins, mark points on the border and quilt top that are ¼, ½, and ¾ of the measurement across the edge of the quilt and along each border piece of fabric. Pin the borders to the top and bottom of the quilt top by matching up these markings. Sew and press toward the border. Follow the same procedure for the side borders. If you add additional borders, follow this sequence for each border. This will keep the quilt square.

Measure width of quilt and add top and bottom borders.

Measure length of quilt and add side borders.

Quilting the Quilt
hand quilting

1. Baste the quilt top, batting, and backing together. For hand quilting, basting with long stitches works well—especially if the quilt is going to be put into a quilting frame or quilting hoop.

2. To baste, place the quilt backing on a hard surface (a floor or large table) with the right side of the fabric facing down and tape down the edges. Lay the batting and then the quilt top (right side up) on top of the backing fabric.

3. Using a large needle, run basting stitches 3" apart horizontally and vertically until the entire quilt top is basted.

machine quilting

If the quilt is going to be professionally quilted on a longarm quilting machine, no basting is necessary.

1. To pin baste a quilt for machine quilting, lay the quilt backing over a table right side down and secure the fabric to the table using bulldog clamps. Be sure to pull the fabric taut. Lay the batting and then the quilt top (right side up) on the backing fabric. Use #2 nickel-plated pins and pin through all 3 layers every 3" until the entire top is pin basted.

2. Start pinning in the center of the quilt and work out to the edges from the center point. Try not to put pins over seams or right in the middle of an area that will be quilted. In this way, there won't be so much starting and stopping to remove pins while machine quilting. If the quilt is larger than the table, pin the section that is on the table and then undo the clamps and move the unpinned section of the quilt onto the table. Reclamp the fabric to the table and pin this section.

3. Remove pins as the quilt is machine quilted.

4. For multicolored quilts, consider using monofilament thread in the needle and cotton thread that matches the backing in the bobbin.

5. Stabilize a quilt with many blocks by quilting along vertical and horizontal seamlines before quilting within the blocks.

6. Quilt in border seamlines (in-the-ditch quilting), working your way toward the edge of the quilt.

7. Complete any quilting within a border before quilting the seam along its outside edge.

Note: In place of pin basting for domestic sewing machine quilting, pay a professional quilter to baste the quilt for you on a longarm machine. This is usually not too expensive and saves you time.

Attaching the Binding and Sleeve

After the quilt is quilted, use a zigzag or overlock stitch on your sewing machine (or use a serger) to secure the edges of the quilt before adding the binding. This will keep the border from shifting as you sew on the binding. A dual feed foot, or "walking foot," will sometimes make it easier to sew along the edge of the three layers. Trim away the excess fabric and batting.

Sleeve: Before sewing on the binding, make a sleeve for hanging the quilt. This can be sewn on as the binding is attached. To make the sleeve, cut a piece of fabric 9" x the width of the quilt. Double fold the two ends (¼" each fold) and sew.

Fold the strip in half lengthwise wrong sides together and press. Hold the sleeve up to the top of the back of the quilt to make sure the length is correct. The sleeve should be at least ½" in from each edge. Center and baste the raw edges of the sleeve to the top of the back of the quilt. Hand stitch the bottom folded edge of the sleeve in place.

Straight edge binding: Cut fabric strips 2¼" wide x the width of the fabric. Sew the strips together diagonally, trim, and press the seam open. Fold the long strip in half lengthwise wrong sides together and press.

Bias edge binding (for use in quilts with curved edges or corners): Cut fabric strips on the bias 2¼" wide. Sew the strips together diagonally, trim, and press the seam open. Fold the long strip in half lengthwise wrong sides together and press.

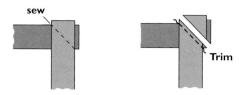

Sew on the diagonal and trim.

Unfold the beginning edge and trim at a 45° angle. Press the trimmed raw edge under ¼". Refold the binding.

Align the raw edges with the quilt top and sew the binding to the front side of the quilt using a ¼" seam. To miter the corners, stitch to ¼" from the corner and backstitch. Fold the binding up and away from the quilt, forming a 45° angle. Refold the binding down, aligning the raw edges with the quilt top. Pin. Begin sewing at the edge and continue to the next corner. Repeat for all four corners.

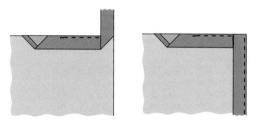

Miter the corners.

As you approach the starting point, trim the end of the binding, making sure there is a 1" overlap to tuck into the fold. Stitch the remaining binding to the quilt. Turn the binding to the back of the quilt, mitering the corner as shown, pin, and hand stitch using a blind stitch.

Fold to the quilt back and hand stitch.

Labels

Attach your label to the back of the quilt. This may include the name of the makers, the place and date the quilt was made, and any other important information (see Labels, page 56).

12

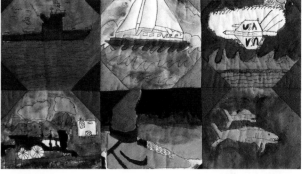

Business Issues

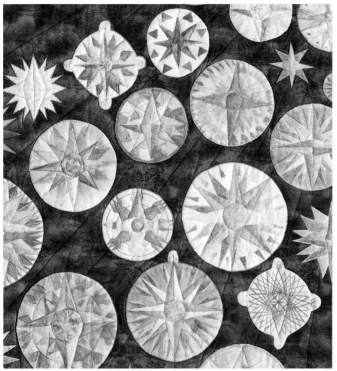

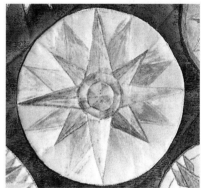

Funding

There may be funds available to help finance or supply materials for your quiltmaking project. Be creative and keep an open mind when researching possibilities.

your school

Some schools have funds available to teachers for extending learning in the classroom. You might also be able to use classroom budgets to purchase supplies. Check with your local teachers' union for possible funding.

the PTA

Your school's PTA organization might be willing to reimburse you for supplies purchased for the project. In one instance, PTA funds were used to buy items that could be shared with other teachers in the school (such as irons and tracing tables). These items actually became part of the library's inventory and could be checked out by teachers for use with their own classes.

the school district

Check with your district, especially the Grants Department, to see if your project qualifies for funding. You might need to reword the project and incorporate curriculum a little differently than originally planned.

local quilt guilds

Many quilt guilds have scholarship or grant money available for projects that teach non-sewers how to sew. Write your proposal so that it asks specifically for the items or money you need. Include items wanted, price quotes, name brands, and so on. Tell the guild how the project will benefit them and how it will be

publicized. If you are asking for money for large ticket items such as sewing machines, include in your proposal what will be done with the machines when you are no longer using them.

local quilt shops

Quilt shops might provide discounted fabrics, thread, and notions. They might also be willing to offer classroom space if you are unable to find space in the building where you work.

sewing machine dealers

If you do not have your own sewing machines, check with local sewing machine dealers to see if they would supply machines. The dealers might also be willing to set up machines for you at your school or offer their store classroom as a workspace.

sewing machine manufacturers

There are a number of sewing machine manufacturers in this country. It is in their best interest that children be encouraged to sew. Contact manufacturers to find out which local dealers they recommend approaching for help with machines. Ask if their regional representatives can help you acquire machines to use on a short-term basis.

thread manufacturers

Write to a thread manufacturer with exact details of your project, including the type and amount of thread you need. Be sure to follow up with a thank you letter and pictures of the completed project.

fabric manufacturers

Ask fabric manufacturers and regional salespeople if they can supply you with fabric samples.

local hobby and craft stores

Many local stores have funds to invest in community projects. Check with them on the availability and requirements for these funds.

local service organizations
(Rotary, Elks, and Other Organizations)

Check with these organizations to see what the requirements are for funds they may have available.

arts councils

Arts councils (national, state, and local level) sometimes have monies available for classroom projects.

Acknowledging Sponsors

However you fund your project, be sure to give that group or organization credit for their generosity. (See Form E, page 91.) Notify local newspapers and publications about the donation, or write an article for your school newsletter. If your school district puts out weekly press releases for the local newspapers, submit information for these releases. Quilt magazines are always looking for articles. Submit an article about your project, and be sure to include pictures! Local news shows are also often looking for a human interest story; notify them of your project.

Permission for Photography/Interviews

If there is any possibility that pictures of the students will be used for TV or print media, you need to have a photograph release permission slip signed by parents. (See Form F, page 92.) Give parents the option of allowing their child's picture and/or name to be used. Keep these slips on file indefinitely.

Graphic Organizer

QUILT THEME: _____

Lang. Arts	Math	Soc. St.	Science	Reading	Technology

Graphic Organizer

QUILT THEME: Symmetry (grade 2)

Lang Arts	Math	Soc. St.	Science	Art	Technology
▪ write a story with pictures ▪ sequence the steps of the project ▪ give an oral description of the project ▪ write a group story about the project ▪ write thank you letters	▪ recognize geometric shapes ▪ properties of symmetry ▪ finding the center of a square ▪ planning the placement of letters in the border by reading a ruler ▪ display data using tallies, bar graphs, pictographs or tables (i.e. graphing shapes in the block by color, shape or number) ▪ multiplication addtion, and division (planning the layout of the blocks for the number of students in the class) ▪ verbally describe patterns ▪ slide, flip, turn concrete materials to create and reproduce simple designs ▪ identifies the lines of symmetry of squares ▪ investigate and predict which Pattern Block shapes can be formed from triangles		▪ observe sponge expansion in water ▪ mixi paint with textile medium	▪ improve eye-hand coordination ▪ practice placement and composition ▪ notice patterns ▪ improve use of tool control ▪ be aware of texture, color, and design ▪ treat tools safely and responsibly ▪ work together to produce a visual product ▪ Use correct spelling, punctuation, and grammar. ▪ Make a book.	▪ use an iron

"The Great Unknown"
Class Quilt
by Mrs. Emmel's 5th Grade

Sewing Groups and Schedule

Group A	Group B	Group C	Group D	Group E

Time	Monday	Tuesday	Wednesday	Thursday	Friday
	A	B	C	D	E
	B	C	D	E	A
	C	D	E	A	B
	D	E	A	B	C
	E	A	B	C	D

Weber School
8275 W. 81st Place
Arvada, CO 80005

Dear Parents,

We are finally working on our Family Tree quilt—the eleventh quilt I have made with Weber fourth or fifth graders! The kids have designed and painted a person in traditional dress from their land of ancestry as well as the flag of that country. Our next step is for the kids to sew together the blocks for the quilt. The two blocks being used this year were designed by two of our classmates. Another student will be designing the large tree for the center of the quilt. Instead of leaves, flags will hang from our tree.

I have five sewing machines that were purchased several years ago with grant money from the Colorado Quilting Council for use in teaching children about quilts and quilting. I will also bring in a sixth machine, and a parent has volunteered a seventh machine so that we can work with all five groups during the school day. We are going to machine piece our quilt blocks on _____, and I need your help!!!

I have listed below the times we will be working (5 to 7 students at a time), which is when I need your help the most. If you are able to help, please mark the time(s) you would be available. I can't tell you how much I appreciate your helping the kids follow directions, thread (and re-thread!) their sewing machines, and press their blocks as they finish each step. You **DO NOT** need to know how to quilt or use a sewing machine in order to help. Any level of expertise is appreciated!

Please return the form below as soon as possible so that I may finalize our schedule. I will try to schedule your child to sew at the same time you will be working with us. I will be setting up the machines in the temporary classroom that is closest to our classroom.

Thanks! I think you will love our quilt!

Kathy Emmel

 I will be able to help make our class quilt during the following time(s) on _____:

_____ 8:40 - 9:40 a.m. _____ 9:40 - 10:40 a.m.

_____ 10:40 - 11:40 a.m. _____ 1:00 - 2:00 p.m.

 _____ 2:00 - 3:00 p.m.

_____ _____

Signature Phone #

Mrs. Emmel and her fifth grade class at Weber Elementary School would like to thank the sponsors of this project who donated over $15,000 worth of equipment, materials, and services.

"It's a Pond's Life"
a quilt made by
Mrs. Emmel's
5th Grade Class at
Weber Elementary
in
Arvada,
Colorado

Sponsors:

Viking Husqvarna Corporation
Wallace Sewing Chalet, Boulder, CO
Dry Creek Quilts, Broomfield, CO
IBM Corporation, Boulder, CO
Colorado Quilting Council
Possibilities Publishing Co., Denver, CO
Weber School PTA
Sulky of America
Oklahoma Embroidery & Design
Hobbs Corporation
Stearns Technical Corporation
G & P Trading, Westminster, CO
Quilts by Sandi, Aurora, CO

Weber School
8725 W. 81st Place
Arvada, CO 80005

"It's A Pond's Life"

A quilt being made by
Mrs. Emmel's Fifth
Grade Class at
Weber Elementary
School,
Arvada, Colorado

Dear Parents,

As you are aware, I have received a sizable grant (valued at over
$15,000) from several sources so that our class may make our quilt,
"It's a Pond's Life," using the most high tech computerized sewing
machine and embroidery software technology. These grants have
come from Viking Corporation, Wallace Sewing Chalet in Boulder,
Dry Creek Quilts in Broomfield, the Colorado Quilting Council,
IBM Corporation, and Weber's PTA.

I will be asking people from the school, other schools in the district,
other teachers in the district, and Colorado Quilting Council to come
and help the children sew during the week of _____. On _____, I will be holding an
Open House from 10 a.m. to 4 p.m. at Weber School in room 24 where we will be sewing all week while
the sixth grade is at Outdoor Lab School. I will be inviting many people to visit on _____ to try out the
machines and the embroidery technology. I will also be inviting many people to come on _____ to
help the children sew. I will also be inviting local and national media (TV, newspapers and magazines) to
interview us and photograph our project.

I need for each child to have this form filled out and returned. This form gives me permission to allow or
not allow your child to be photographed and his or her name to be used in the media. Please indicate your
preferences on the form below.

Thank you for your help,
Kathy Emmel

**

My child, _____, **DOES HAVE** my permission to
be photographed during the week of _____.

My child, _____, **DOES NOT HAVE** my
permission to be photographed during the week of _____.

_____ Yes, **I DO GIVE** my permission for my child to be interviewed during the week of _____.
_____ No, **I DO NOT GIVE** my permission for my child to be interviewed during the week of
_____.

My child _____**MAY** or _____**MAY NOT** have his or her named used in publications.

Parent's Signature: _____

Date Signed: _____

**Shapes for appliqué
practice (see page 34)**

Resources

For information on Setacolor Textile Paints and wax resist:
Pro Chemical & Dye
PO Box 14, Somerset, MA 02726
508-676-3838
www.prochemical.com

For information on Jacquard Textile Paints
Rupert, Gibbon and Spider, Inc.
P.O. Box 425
Healdsburg, CA 95448
www.jacquardproducts.com

For information on Liquitex acrylic paints:
www.liquitex.com

Craft Stores
Hobby Lobby,
www.hobbylobby.com

JoAnn Fabrics, www.joann.com

Michaels, www.michaels.com

Oil Paintsticks
Shiva, A Richeson Co.,
Kimberly, WI 54136

Delta fabric paints
Delta Technical Coatings, Inc.,
Whittier, CA
www.deltacrafts.com

Regular Crayons
Crayola, Binney & Smith,
1-800-CRAYOLA
www.crayola.com

Fabric Crayons
Dritz
W.H. Collins, Inc.
Spartanburg, SC 29304
www.dritz.com

FabricMate markers
Yasutomo
So. San Francisco, CA 94080
www.yasutomo.com

DecoFabric Markers
Marvy/Uchida by Uchida of AmericaCorp.
Torrance, CA 90503
www.marvy.com

Setaskrib fabric markers
Pebeo
www.pebeo.com

Sewing Machine Manufacturers
Husqvarna Viking Corporation
www.embroiderylibrary.com

Bernina Corporation,
www.berninausa.com

Pfaff Corporation, www.pfaff.com

Elna Corporation, www.pfaff.com

Singer, www.singerco.com

Janome, www.janome.com

Brother, www.brother.com

Die-Cut Machine
Ellison Educational Equipment
25862 Commercenter Drive
Lake Forest, CA 82630
www.ellison.com

Pattern Blocks
www.learningresources.com

Possibilities, Publishers of the I Can Teach Myself sewing series for children, www.possibilitiesquilt.com

Photo Printing Fabrics
June Tailor, www.junetailor.com

Jacquard,
www.jacquardproducts.com

Printed Treasures,
www.printedtreasures.com

Miracle Fabric Sheets
www.cjenkinscompany.com/miraclefabric.html

Color Textiles
www.colortextiles.com
Has a variety of fabrics, including poplin, broadcloth, and silk, and rolls of fabric for banner printing

Thread
Sulky, www.sulky.com

Robison-Anton,
www.robison-anton.com

Madeira, www.madeirausa.com

Isacord,
www.ackermanna.com/isacord.html

Compressed Sponge Material
Loew-Cornell, Inc.
563 Chestnut Avenue
Teaneck, NJ 07666-2490
www.loew-cornell.com

OR

Absorene Manufacturing Company
Sponge Producers Division
Gulf & West Indies Division
2141 Cass Ave.
St. Louis MO 63106
800-662-7399 or 314-231-6355
fax: 314 231-4028
www.absorene.com

Light Tables and Projectors
www.artograph.com

About the Author

Photo courtesy of www.goimages.com

As a very young child, Kathy Emmel loved art and art supplies. Her grandmother and mother were instrumental in allowing her to try many techniques and media including sewing and quilting. At age 8, Kathy decided she wanted to be a teacher. With the encouragement of wonderful elementary and high school art teachers and her father (who encouraged her to pursue that which she loved most), she majored in art in college and earned a K-6 classroom and art specialist teaching license.

Kathy taught in public schools for almost 30 years and during 17 of those years, she made large group quilts with second through sixth grade children. A Master's Degree in Creative Arts solidified her belief that children learn best though hands-on, arts-based techniques.

As accountability and testing in public schools became more common, the need arose to document the integration of curriculum and to teach in as many subject areas as possible using an art project (in this case, a quilt) as the tangible outcome of all the skills being taught. The graphic organizer in chapter 1 will help the reader realize the wide range of content areas that can be taught using a quilt as a project.

As a quilter, Kathy has made more than 100 quilts since the 1970's and continues to love working with fabric and design. She is active in the Colorado Quilting Council and has been their newsletter editor since 1999. She also serves on the board of the Rocky Mountain Quilt Museum and edits their newsletter as well.

Her quilts have been exhibited at the Rocky Mountain Quilt Museum, the Museum of the American Quilters Society, the International Quilt Festival, the Vermont Quilt Festival, the American Quilters Society Show, Quilt Expo in Barcelona Spain, the Road to California Show, the Husqvarna Viking National Convention, the Kokusai Art Traveling Exhibit, Tokyo, Japan and at local venues throughout Colorado.

Her wish is for the reader to encourage children to be artists and to help them learn to express themselves through their art.